apropos RODIN

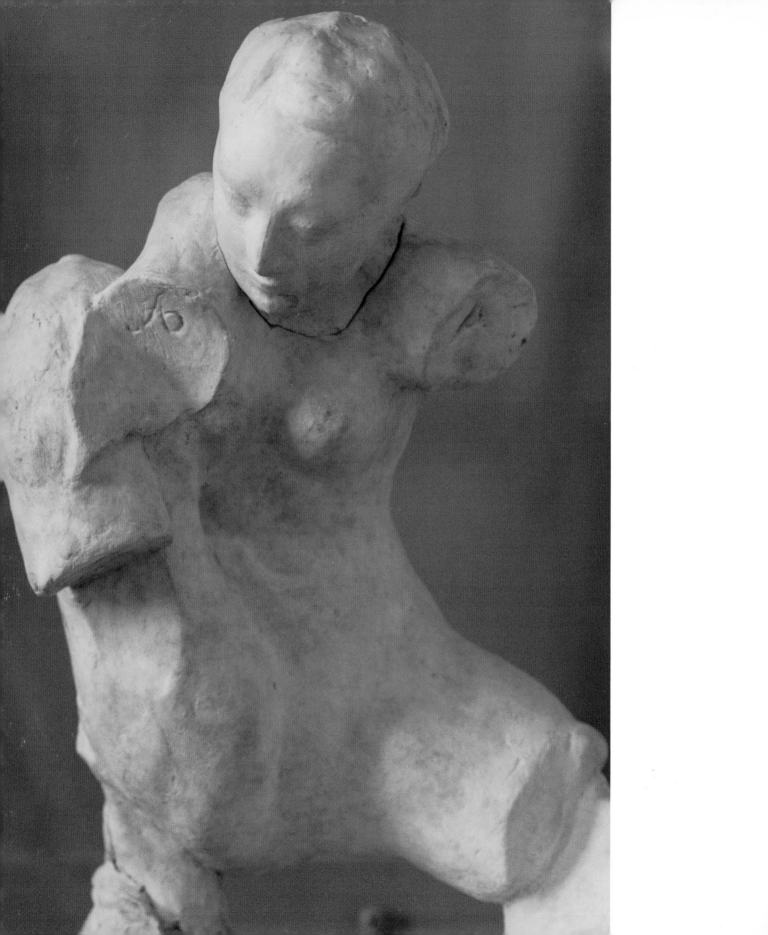

Jennifer Gough-Cooper

Geoff Dyer

apropos.
RODIN

with 73 photographs in color

Thames & Hudson

The publishers would like to express their special thanks to the Musée Rodin, Paris, and its Director, Dominique Viéville, for their most generous support. In particular, to Madame Hélène Pinet, Curator of the Photographic Collections at the museum, our warmest thanks for her close collaboration, valuable assistance and encouragement at every stage.

Between 25 October 2006 and 21 January 2007 "Rodin – L'Éveil de la pierre", an exhibition of selected photographs from the book, will be held in the Cabinet d'Arts Graphiques, at the Musée Rodin, Hôtel Biron, 79 rue de Varenne, 75007 Paris.

Frontispiece: TORSO OF IRIS, *no date, plaster*

First published in 2006 in hardcover in the United States of America by
Thames & Hudson Inc., 500 Fifth Avenue, New York, New York 10110

thamesandhudsonusa.com

Library of Congress Catalog Card Number 2005911285

ISBN-13: 978-0-500-54319-1
ISBN-10: 0-500-54319-4

Designed by Trix Wetter
Printed and bound in Singapore by CS Graphics

Contents

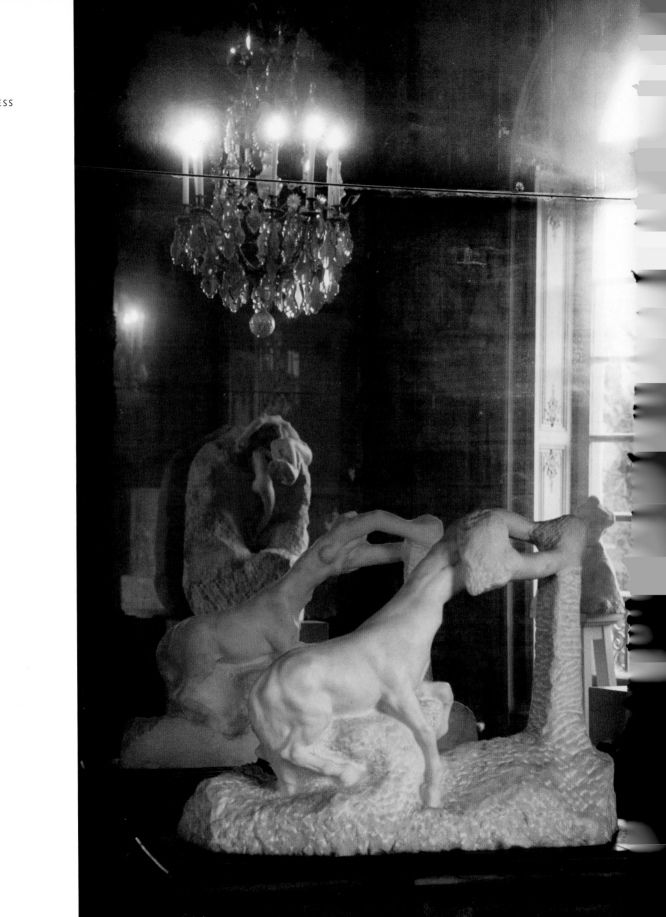

THE CENTAURESS
1901–4, marble

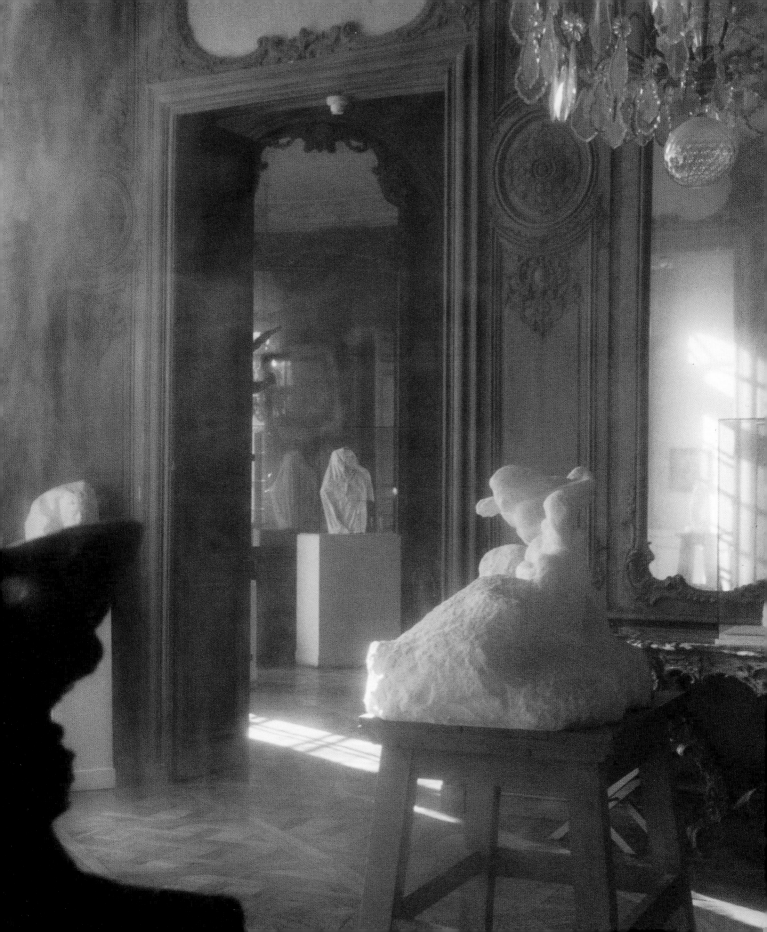

ETERNAL IDOL
No date, plaster

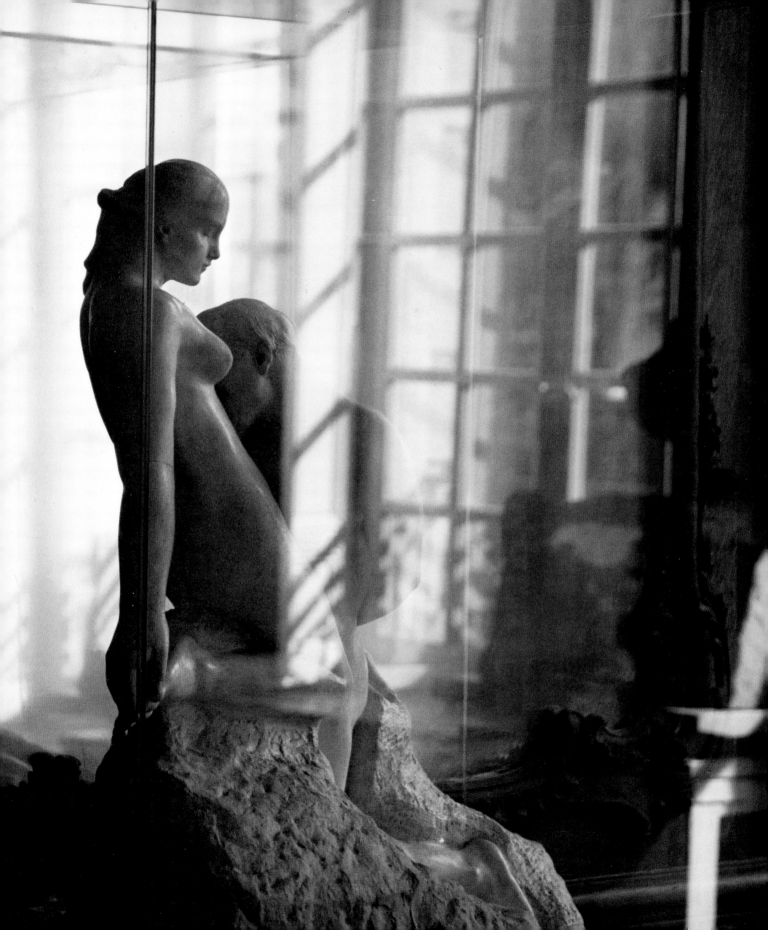

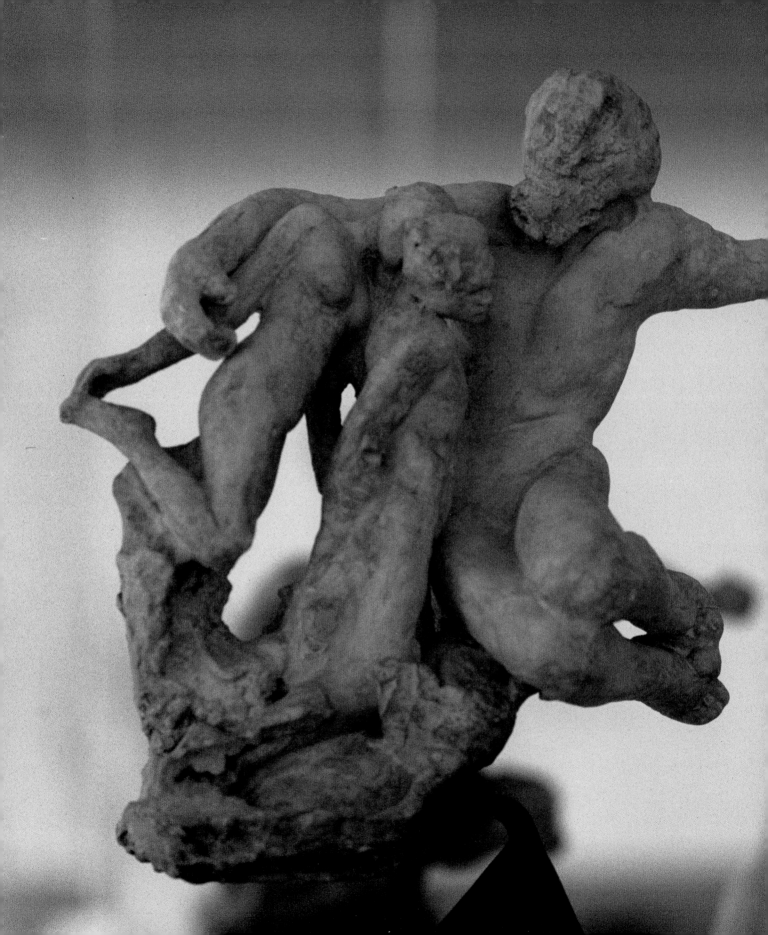

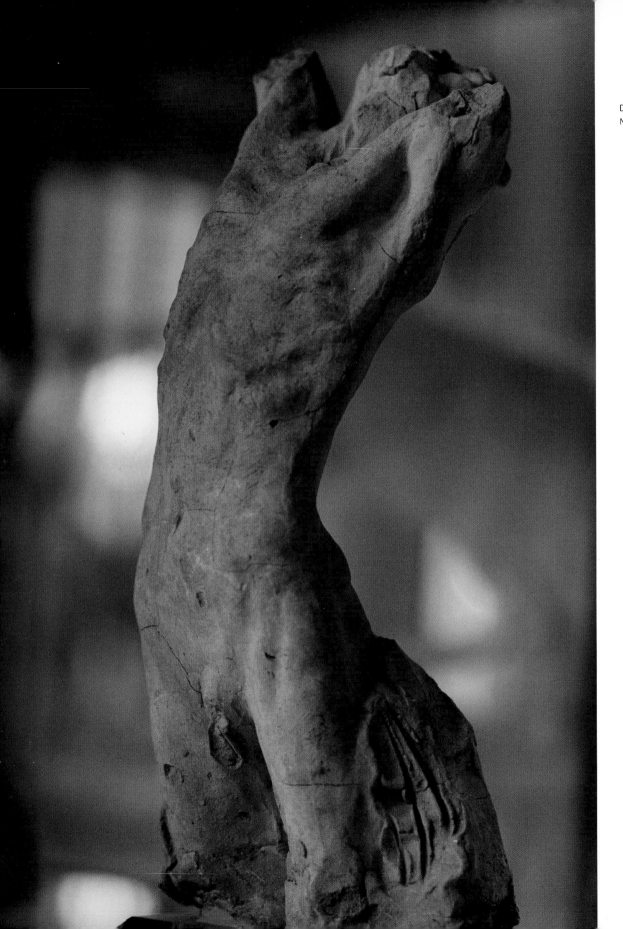

The Awakening of Stones

I'VE NEVER BEEN DIRECTLY INTERESTED IN RODIN, but so many other interests have drawn me to him that he feels, in some ways, a source to which I have been insistently urged. Can an account of the journey towards it serve as a surrogate description of the source itself?

I FIRST READ ABOUT RODIN IN *Art and Revolution*, John Berger's book about Soviet sculptor Ernst Neizvestny. Rodin was an important influence on Neizvestny, but before discussing the work of either man Berger offers a general consideration of sculpture's relation to space.

'Compare a sculpture with a tree in winter. Because a tree grows, its forms are changeable and this is implicit in their shapes and configuration. As a result its relation to the surrounding space appears to be an adaptive one.' Berger then compares a sculpture with a building and a machine. Having done that, he is ready to specify the way a sculpture 'appears to be totally opposed to the space that surrounds it':

> Its frontiers with that space are definitive. Its only function is to use space in such a way that it confers meaning upon it. It does not move or become relative. In every way possible it emphasizes its own finiteness. And by so doing it invokes the notion of infinity and challenges it.
>
> We, perceiving this total opposition between the sculpture and the surrounding space, translate its promise into terms of time. It will stand against time as it stands against space.[1]

From that point on I was conscious of and curious about sculpture – if only in a vague and passive way.

I NEXT ENCOUNTERED RODIN IN CONNECTION WITH RILKE, who had arrived in Paris in 1902 to write a monograph on the sculptor. 'I am coming to Paris this autumn to see you and steep myself in your creations,' he announced to Rodin in June of that year.[2] In spite of the language barrier – Rilke's French at that time was poor and Rodin had no German – the young poet was as impressed by the master,

when he met him, as he was enthralled by his creations. Rilke spent a good deal of time in Rodin's company, wrote his book about him in a month, and resumed his peripatetic life the following March. Rodin showed little interest in the book, but when he read a French translation, in 1905, he wrote warmly to the man who had 'influenced so many by his work and his talent.'[3] Expressing affection and admiration, Rodin invited Rilke to stay at his home in Meudon. The reunion, a few months later, was everything that Rilke could have hoped for. He found himself not only integrated into Rodin's busy round of activities and obligations but helping to organize them. It was a logical next step – or, perhaps, a temptingly illogical one – for the poet to become the sculptor's secretary. The arrangement worked well enough for a while, but Rilke soon began to feel overburdened by his duties. In May 1906 Rodin discovered that the secretary had become over-familiar in letters to some of his friends – and sacked him on the spot ('like a thieving servant,' as the grievously wounded Rilke put it).[4]

I read Rilke's book ten years ago, not because of who it was about, but because of who it was by. Actually, the distinction crumbles even as it is made since this unique account of genius by a genius, as Rilke himself told Lou Andreas-Salomé, 'also speaks about me.'[5] If this became even more evident *after* it was written, that is because Rilke's early exposure to Rodin had such a determining effect on his subsequent career. From Rodin he became convinced of the absolute importance of incessant work, of unswerving dedication to a vocation. It was Rodin, apparently, who advised him to 'just go and look at something – for example, at an animal in the Jardin des Plantes, and keep on looking at it till you're able to make a poem of that.'[6] 'The Panther' may have been the direct result of this suggestion. More generally, Rilke fought to directly translate what he considered the sculptor's most distinct quality – his ability to create *things* – into 'thing-poems' [*Dinggedichte*]. This entailed more than just looking; as with Rodin, 'one might almost say the appearance of his things does not concern him: so much does he experience their *being*.'[7]

The way that Rodin awakened in Rilke the desire to create poems that were the verbal equivalents of sculptures is quite explicit. 'The Song of the Statue', for example, records a longing to

> be brought back from stone
> into life, into life redeemed.[8]

ON HIS VERY FIRST VISIT TO RODIN'S STUDIO on rue de l'Université, Rilke was struck by a bas-relief called *Morning Star*:

> A young girl's head with a wonderfully clear brow, clear, sweet, light, and simple, and deep down in the stone a hand emerges, shielding the eyes of a man, waking, from the brightness. These eyes are almost in the stone (so marvellously is the unawakenedness expressed here...).[9]

The following day, on his first visit to the pavilion at Meudon, Rilke was exhausted, both by the quantity of things on display and by their snow-bright whiteness – so dazzling that it hurt his eyes. Speculating on the origins of Rodin's own sense of vocation, Rilke wondered about the antiquities he must have seen as a youth, in the Louvre and elsewhere:

> There were stones asleep, and one felt that they would awaken at some Judgement Day, stones which had nothing mortal about them, and others embodying a movement, a gesture, which had retained such freshness that it seemed to be preserved here only until some passing child should receive it one day as a gift.[10]

Rodin himself, in *Cathedrals of France*, voiced his belief in sculpture as an 'incantation by which the soul is brought down into the stone.' Looking at the work of Gothic carvers, he was amazed 'that one should be able to capture the soul's reality in stone and imprison it for centuries.'[11] Sometimes, Rodin said, a knot of wood or a block of marble made it seem 'that a figure was already enclosed there and my work consisted of breaking off all the rough stone that hid it from me.'[12] On the base of the bronze cast of *I Am Beautiful* he had inscribed lines from another poet, Baudelaire, beginning: 'I am beautiful as a dream of stone.'[13]

As can be seen from this rag-bag of quotations, the relation between these linked ideas is not fixed – not set in stone, as it were. There is a fluid and supple movement between the idea of the stone imprisoning and containing, of its sleeping and dreaming, of its waking and coming back to life. The stone contains the figure, and the figure released from the stone imprisons the living being contained within it. The task of Rilke's words – both in his own poetry and in his book on Rodin – was to record this simultaneous sense of deeper and deeper recesses of oneiric inwardness within the stillness of the stone, and of constant awakening, of emerging into being. The process is additionally

BALZAC, BAUDELAIRE AND PUVIS DE CHAVANNES
Plaster

complicated by the way that Rodin – unlike Michelangelo who also spoke of freeing figures from stone – did no carving. He was a modeller, forming clay figures with his hands. From the moulds derived from these clay figures plaster versions could be cast; from the plaster figures other moulds could be made, from which a bronze casting might eventually be made. (All the marble versions of Rodin's work were carved by assistants.) There is in other words, a succession of confinings and freeings, of imprisonment and release, of positives and negatives; a constant inverting of the idea of inside and out, of exterior and interior. As Rilke succinctly phrased it, 'surroundings must be found within.'[14]

Rilke's sense of the importance of what he was experiencing in the course of his immersion in Rodin's work was intense and immediate. So much so that he hinted at how it might appear in retrospect, in the poem 'Memory' (published, like 'The Song of the Statue', in the second, 1906, edition of *The Book of Images*).

> And you wait, you wait for the one thing
> that will infinitely increase your life;
> the mighty, the tremendous thing,
> the awakening of stones,
> depths turned to face you.
>
> On bookshelves, volumes gleam
> in gold and brown;
> and you think of lands travelled through,
> of pictures, of the dresses
> of women lost once more.
>
> And all of a sudden you know: that was it.
> You rise, and there before you stand
> the fear and form and prayer
> of a year gone by.[15]

The idea of the past imagined as a future, of the long-anticipated having already occurred, reflects, in temporal terms, the sense – inherent in Rodin's method of working – of the outside within, of surface being formed within the depths of something else. Rilke came back to this repeatedly: 'the mobility of the gestures...takes place within the things, like the circulation of an inner current.'[16]

Describing Rodin's technique he wrote, 'Slowly, exploringly he had moved from within outwards to its surface, and now a hand from without stretched forward and measured and limited this surface as exactly from without as from within.'[17] William Tucker, in his book *The Language of Sculpture*, summarizes Rilke's observations in terms of 'the identity of external event with internal force: clay is felt as substance, not *over* the surface but *through* every cubic inch of volume.'[18]

These reconciled oppositions, as essential to Rilke's ongoing metaphysical project as they are to Rodin's physical objects, can be seen operating in another way too. Rodin, according to Rilke, saw better than anybody that the beauty of men, animals and things was 'endangered by time and circumstances'. Seeking to preserve this threatened beauty, he adapted his things 'to the less imperilled, quieter and more eternal world of space.'[19] As Rodin's career proceeded, so the relation of the work to what surrounded it changed; 'whereas formerly his works stood in the midst of space, it now seemed as if space snatched them to itself.'[20] What is going on in the depths of the figures is being sucked to the surface. Hence the intense gestural drama of Rodin's work, the sense of the surface brimming with what is within.

Rilke's discussion of how Rodin adapted the temporally transient to the permanence of space intersects, at this point, with Berger's. Berger, it will be recalled, began by contrasting the relations to space of tree and sculpture, but for Rodin the distinction was not as clear-cut. In *Cathedrals of France* he declares that 'between trees and stones [he sees] a kinship,' that his sense of sculpture owes much to trees and forests: 'Where did I learn to understand sculpture? In the woods by looking at the trees....'[21]

It so happens that a poem of Rilke's about a tree expresses very clearly the dialectic of surface and depth, of inwardness and outwardness, that is so crucial to Rodin's art. To be strictly accurate, it is not just the poem itself but the way I encountered it that makes it so pertinent. (Contingency and serendipity play their part in this journey. What is an account of a journey, after all, if not an organized succession of contingencies?) I first read the poem – written, originally, in French – in Gaston Bachelard's *The Poetics of Space*. The lines 'Arbre toujours au milieu/De tout de qui l'entoure' are here translated as 'Tree always in the centre/Of all that surrounds it.'[22] Curious to see what these French poems of Rilke's were like, I bought *The Complete French Poems* which presents

the original French in tandem with an English translation. In this version the meaning of the passage from 'Le Noyer' ('Walnut Tree') is reversed:

> Tree, ever at the centre
> Of whatever it surrounds...[23]

This is clearly wrong – nonsensical even – but the combination of these two versions accords with Rodin's method of working, the way the figures are always at the centre of whatever surrounds them and are always surrounding whatever is at their centre.

As with sculpture so with photography: the first things I read about it were by John Berger. I became interested in photography after reading about it. Years later, when I became interested in photographs of sculpture, two tributaries joined together, urging me more powerfully in the direction of Rodin (it is appropriate, given the inversion of surface and depth, that the metaphor here tends towards the mouth when I mean the source).

One of the earliest uses of photography was to make visual records of works of art. With the technology not yet responsive to the full range of colours, sculpture lent itself more readily to this undertaking than painting. The writer James Hall thinks that 'Louis Daguerre's first relatively permanent photograph was probably a still-life with plaster casts.'[24] In 'Some Account of the Art of Photogenic Drawing' (1839) William Henry Fox Talbot outlined one of the uses to which he intended to put his 'invention': 'the copying of statues and bas-reliefs.... I have not pursued this branch of the subject to any extent; but I expect interesting results from it, and that it may be usefully employed under many circumstances.'[25] Five years later, in *The Pencil of Nature*, his picture of a bust of Patroclus offered abundant proof that 'statues, busts, and other specimens of sculpture, are generally well represented by the Photographic Art.'[26]

So well that David Finn – to leap forward a century and a half – was able to persuade Kenneth Clarke and Mario Praz that photographs of sculpture could enable people 'to discover qualities in a work of art that might not be immediately apparent even to a knowledgeable and critical viewer.'[27] Finn also suggests that, whereas photographs of complete sculptures often reveal stylistic traits or conventions which date the work and distract the viewer, photos like his (which, typically, isolate parts of a larger whole) reveal what is elemental,

timeless. By doing so, by freeing them from the grip of convention and the period in which they were made, the stones are brought to life.

When it comes to photographing the works of Rodin this strategy is both appropriate and, in a sense, superfluous, because the sculptor himself often concentrated on parts of the body. If the fragment is, as Linda Nochlin suggests, 'a metaphor of modernity', then Rodin's eagerness to exhibit dismembered body parts as completed works of art is one of the ways in which the twentieth century can be felt beckoning in the nineteenth.[28] This is not the only congruity between photography and Rodin's working methods.

In her contentious essay 'The Originality of the Avant-Garde' Rosalind Krauss points out that, like Cartier-Bresson, 'who never printed his own photographs, Rodin's relation to the casting of his own sculpture could only be called remote.' The fact that the plasters are themselves casts – i.e. 'potential multiples' – illustrates how deeply Rodin's method was steeped 'in the ethos of mechanical reproduction.' The same figures recur endlessly, in new contexts, in new permutations, in new arrangements, in new sizes, in new materials. Many of these figures were first glimpsed in the molten swirl of *The Gates of Hell* (which Rodin referred to as his 'Noah's ark'); since the monument was never cast in the sculptor's lifetime – and thus, in a sense, never completed – Krauss views Rodin's as 'an art of reproduction, of multiples without originals.'[29]

Needless to say, any equation of his art with the camera's capacity for copying or passive recording would have enraged Rodin in the same way that allegations that his *Age of Bronze* was cast from life had done in 1877: 'Many cast from nature, that is to say, replace an art work with a photograph. It is quick but it is not art.'[30] Resolutely insisting that 'it is the artist who is truthful and it is photography which lies,' Rodin made clear his distaste for photography on many occasions.[31] He was scarcely less obstinate in his aversions as an observer than he was as creator:

> Photographs of monuments are mute for me. They do not move me; they allow me to see nothing. Because they do not properly reproduce the planes, photographs are for me always of an unendurable dryness and hardness. The lens of the camera, like the eye, sees in low relief. Whereas, looking at these stones, I feel them! My gaze touches them everywhere as I move about to see from all sides how they soar in every direction under the heaven and from all sides I search out their secret.[32]

In spite of these specific and generalized objections Rodin, especially from the mid-1890s onwards, took advantage of the full range of advantages and opportunities afforded by photography. He used photos as tools to revise and edit his works in progress, indicating in pen changes to be made later to the figures themselves. He included photographs of his sculptures in exhibitions. Alert to their value in making his work available in another, easily disseminated form, he used photographs to publicize, enhance and spread his reputation, to help the idea of his matchless originality to proliferate. After seeing the Rodin exhibition at London's Hayward Gallery in 1986, one reviewer even went so far as to suggest not only that 'the photographic images may often have a stronger presence than the actual works', but that Rodin 'may often have consciously sought for an effect that was aimed at the two-dimensional mass-reproduction of his work, rather than its three-dimensional solitude.'[33]

Rodin did not take photographs himself, preferring to rely on the skills of a small but changing group of skilled and trusted collaborators. The most important of these was Edward Steichen who achieved in photography the equivalent of what Rilke managed in prose: a supremely individualized account in which the work and the man who made it were perfectly mirrored. Steichen's composite image of Rodin silhouetted in front of *The Thinker* and the *Monument to Victor Hugo* (1902) and the brooding long exposures of the Balzac monument at night (1908) captured the sculptor's imagination in a way that he had not previously believed possible. In person Rodin was, by all accounts, a modest man; at the deepest level, though, the test of photography – its greatest challenge, in fact – was whether it could do justice to his genius. On seeing Steichen's Balzac prints, Rodin was immediately convinced, informing him that he would 'make the world understand my Balzac through these pictures. They are like Christ walking in the desert.'[34] Rodin's enthusiasm for Steichen – 'Before him nothing conclusive had been achieved' – was such that it caused him profoundly to reconsider the value of photography which, he conceded in 1908, 'can create works of art.'[35] The collaboration was beneficial to sculptor and photographer alike. Of the portrait of Rodin and *The Thinker*, Steichen recalled that it was 'undoubtedly the image that launched me in the photographic world.'[36]

I APPROACHED JENNIFER GOUGH-COOPER'S PHOTOGRAPHS not with Rodin's magisterial scepticism but with a degree of impatience. There were other things I

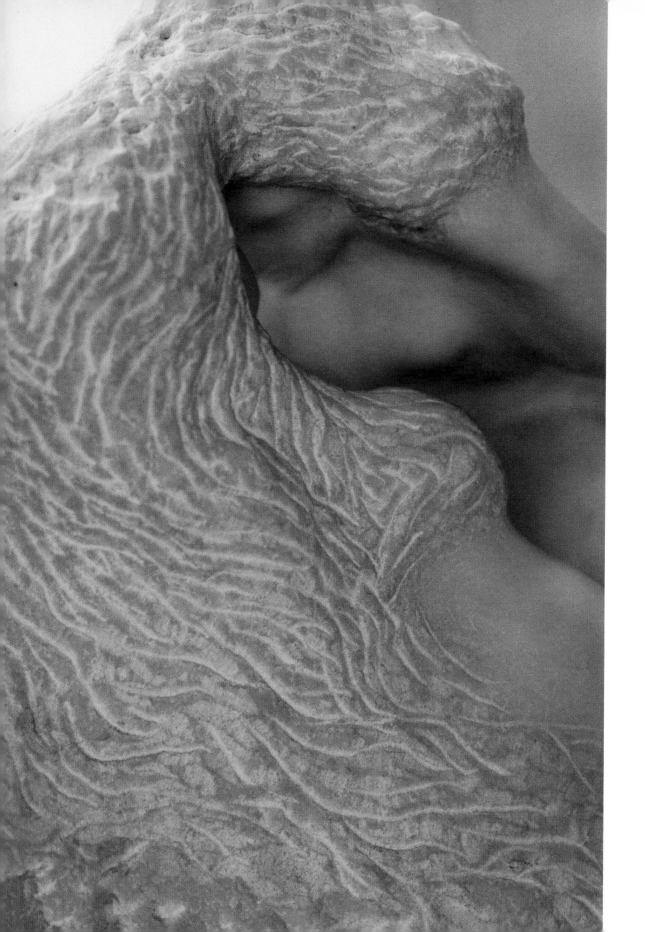

NYMPHS PLAYING
c. 1900, *marble*

was supposed to be doing, other things I was meant to be looking at, and I hoped that they would not detain me, that I could look at them quickly. These hopes were accurate and wide of the mark in that it took only a brief look for any desire to move on to be immediately extinguished. Although I didn't realize it at the time, the reason for this was, perhaps, that these pictures had brought me so close to the source, to Rodin himself. I couldn't take my eyes off them. Rilke had been dazzled by the snow-bright whiteness of Rodin's work; Gough-Cooper subtly reminds us that white is itself a colour, endlessly susceptible to changes of angle and light. At times it can even seem – how else to put it? – flesh-coloured. As Krauss had seen a connection between the endless reproducibility of the photograph and Rodin's working methods so, here, another, slower relationship was evident: between the images emerging gradually in the tray of chemicals and the figures' emergence into form. 'Stone is so still,' sighs the statue in Rilke's song. Still photography is the logical medium for conveying stillness, but one's first reaction on seeing Gough-Cooper's pictures is not of stone's stillness but its *softness*. The figures yield to the oddly tactile gaze of the camera. It is not just flesh but *hair* that plays a part in this response.

Nothing, I suspect, causes sculptors more trouble than hair. How to render it as strands rather than as a finely corrugated lump? Sculpted hair has to be light but in stone, clay, bronze or marble it tends to weigh the figure down like an anchor. Gough-Cooper makes it possible to believe that, if Rodin's figures were tossed into the sea, their hair would float above them. Rodin said that 'a woman who combs her hair fills the sky with her gesture.'[37] In Gough-Cooper's photographs the hair of Rodin's women is full of sky; the 'h' becomes silent, their tresses airy.

All this talk of hair, though, is somewhat of an evasion for it was, frankly, the enormous erotic power of the photographs that transfixed me. Undeniable in the originals, the sexual content of Rodin's work is, if anything, more intensely felt in these photographs. Given the volume of sexually explicit visual material currently pouring across the Internet, it is initially surprising that photographs of these masterpieces of nineteenth-century art can be so charged; but that surprise also provides a clue as to how a medium exclusively concerned with the visible, limited to the surface, can reveal something deeper, something hidden in the depths of the stone.

Generally speaking, Rodin's sculptures of men show them in some kind of torment or anguish. Rodin made much of the idea of himself as the creator – all those versions of *The Hand of God* – but his male creations rarely respond with gratitude. Rather they react like Adam, lamenting his fallen condition in *Paradise Lost* (in lines used by Mary Shelley as the epigraph to *Frankenstein*):

> Did I request thee, Maker, from my clay
> To mould me Man, did I solicit thee
> From darkness to promote me...?[38]

Rodin's male figures show the agony of coming to life, the pain, to put it somewhat clumsily, of becoming alive. This awful jolt into consciousness is felt most clearly in *The Burghers of Calais*.

The immediate inspiration for Rodin's monument was an episode from 1347, when Edward III agreed to spare the rest of the population of the besieged city of Calais if six men turned themselves over to him. Inspired by the example of Eustache de Saint-Pierre, five more of the most prominent citizens of Calais volunteered to join him. The meaning of the finished sculpture goes far beyond the incident in which it originated (and of which many of us today are, in any case, ignorant). Rodin's sculpture shows men weighed down not by fate but by choice, regretting the decision that has emboldened them, pierced and penetrated by the consciousness of what they have done. The gravity of what they have inflicted on themselves causes the sky to bear down on them with atrocious force. Called on to make a gesture – of self-sacrifice – the ennobling ideal of martyrdom is undermined and betrayed by their gestures.

Written in damning response to a two-foot-high maquette prepared by the sculptor, an article in the Calais *Patriote* of 2 August 1885 was wildly wrong in its judgment but accurate in its summing up of 'the feelings emanating from the work, in general' as 'sorrow, despair, and endless depression.'[39] The men put themselves forward willingly enough, but the force of their decision is not enough to propel them through its consequences. For all its grandeur, there is a persistent sense of futility about the whole scene. 'Was it for this the clay grew tall?'[40] Since the question was asked by Wilfred Owen in 1918, in his poem 'Futility', the anguished gestures of the burghers have been repeated and echoed not only in photographs of war and suffering but in sport and on the street. Certain gestures are, as Rodin believed, eternal but it does not follow

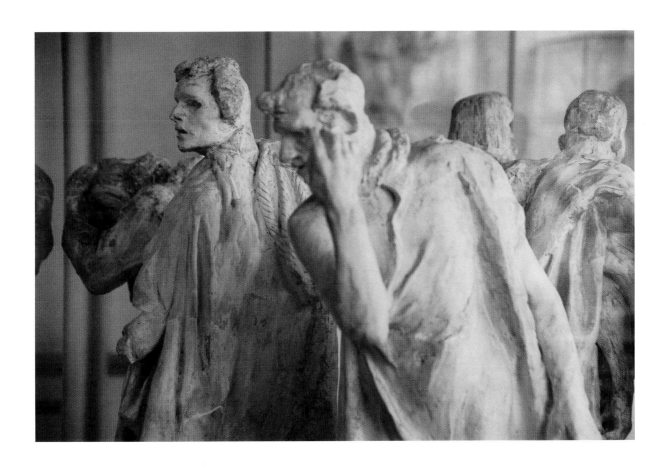

from this that their meaning is constant, unchanging. What Rodin depicted in *The Burghers* was the birth of a specifically modern *form* of despair: an acceptance that there is no external source of redemption and the knowledge that one's life might not be capable of generating its own capacity for redemption.

What solace is available in the face of this dilemma? One possibility is work ('Adam's Curse', as Yeats called it), the unswerving devotion to a craft that so impressed Rilke. (Perhaps this is why the various versions of the *Balzac* are so brazenly undespairing; the novelist surpassed Rodin in his indefatigable capacity for labour.) The other is the sexual promise offered by women. In his later years Rodin achieved a blissful combination of these possibilities, devoting hours and hours to making thousands of drawings of naked women, often in states of sexual rapture. 'People say I think too much about women,' he explained. 'Yet after all, what is there more important to think about?'[41] In Milton – as in the Bible – the Fall comes after Adam has tasted Eve in all her tainted sensuality. This inverts the reality of the situation: that the lure of sex is one of the things that makes the fallen state not simply bearable but desirable. Wittingly or not, Milton provides a glimpse of a paradise that is endlessly regainable:

> Carnal desire inflaming, he on Eve
> Began to cast lascivious eyes, she him
> As wantonly repaid...[42]†

Another John – Updike – offers an extended meditation on this towards the end of *Villages*, a novel written in his early seventies:

> Sex is a programmed delirium that rolls back death with death's own substance; it is the black space between the stars given sweet substance in our veins and crevices. The parts of ourselves conventional decency calls shameful are exalted. We are told that we shine, that we are splendid, and the naked bodies we were given in the bloody moment of birth hold all the answers that another, the other, desires, now and forever.[43]

Rodin trained himself to draw without taking his eyes off the women who were happy to surrender themselves to him as he abandoned himself to his gaze. (William Rothenstein, to whom Rodin made the remark about the importance of women, recalls him 'caressing [his models] with his eyes, and sometimes too with his hands.')[44] His hand functioned like the needle of an exquisitely

calibrated machine, instantly adjusting itself to the models' every move. He wanted nothing – not even himself – to impede the current passing between the model and the paper. Looking and creating art were one and the same. And this late obsession with drawing did not constitute a new beginning or a break with his earlier practice; it was, Rodin insisted, a direct result of his sculpture – or 'drawing in depth' as he called it.[45]

Gough-Cooper's photographs enable us to gaze on Rodin's depth-drawings with the same intensity and absorption that he regarded – in very different ways – the men and women who modelled for him. What she has photographed is nothing less than the awakening of stone, stone awakening to the camera's touch.

GEOFF DYER

[†] *The Gates of Hell* is consistent with Blake's famous insight that Milton was of the devil's party without knowing it. Rodin's Hell seethes with voluptuous allure. Every hint of anguish and torment expressed by the males is balanced and compensated by the writhing sensuality of the women. The most intensely sexual elements of *The Gates* are in the box-like tympanum above the lintel on either side of *The Thinker*. The arrangement has since been adapted by newsagents who stack sexually 'offensive' material out of harm's way – but still within reach – on the top shelf. And if *The Gates* themselves are intended to offer some clue as to what *The Thinker* is thinking then it is hard not to conclude that the figures on either side of him function as the sculptural equivalent of thought balloons in comics.

'FORMERLY I CHOSE MY MODELS AND INDICATED THEIR POSES.

 I HAVE LONG LEFT THAT ERROR BEHIND. ALL MODELS ARE INFINITELY BEAUTIFUL,

AND THEIR SPONTANEOUS GESTURES ARE THOSE

THAT ONE FEELS ARE THE MOST DIVINE.'

Auguste Rodin, *Cathedrals of France*

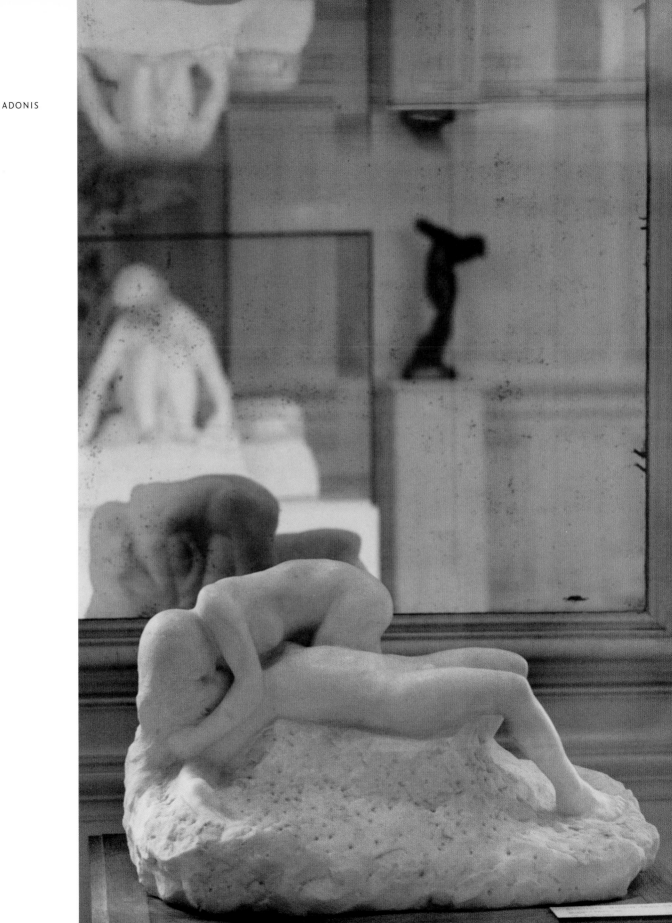

THE DEATH OF ADONIS
1895, marble

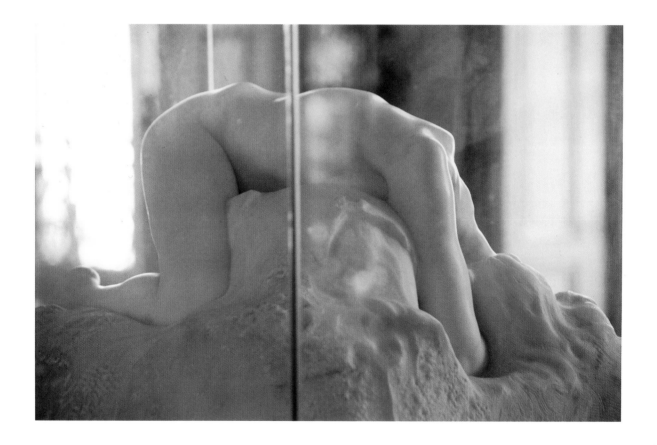

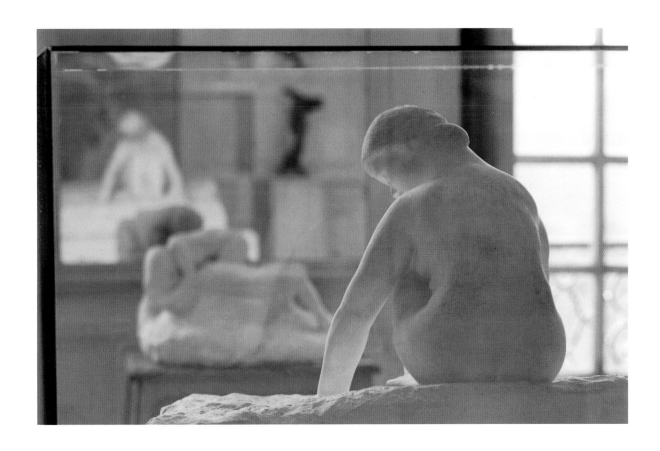

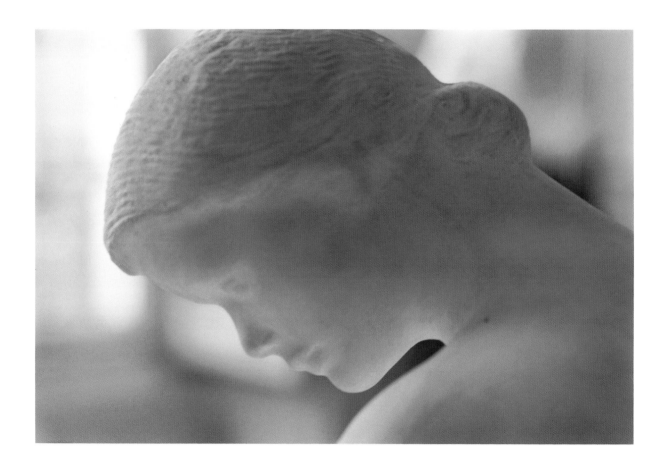

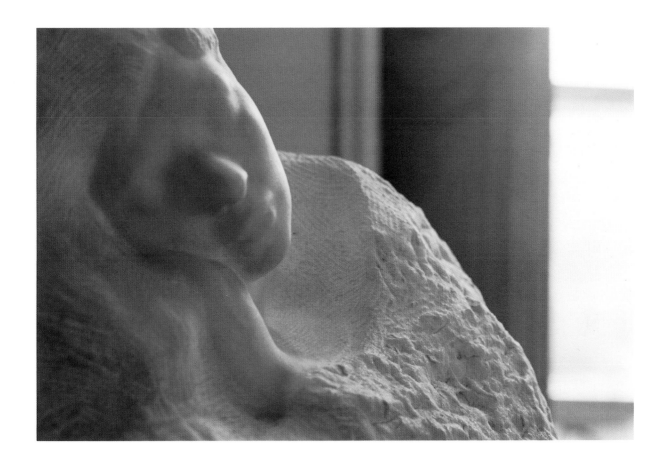

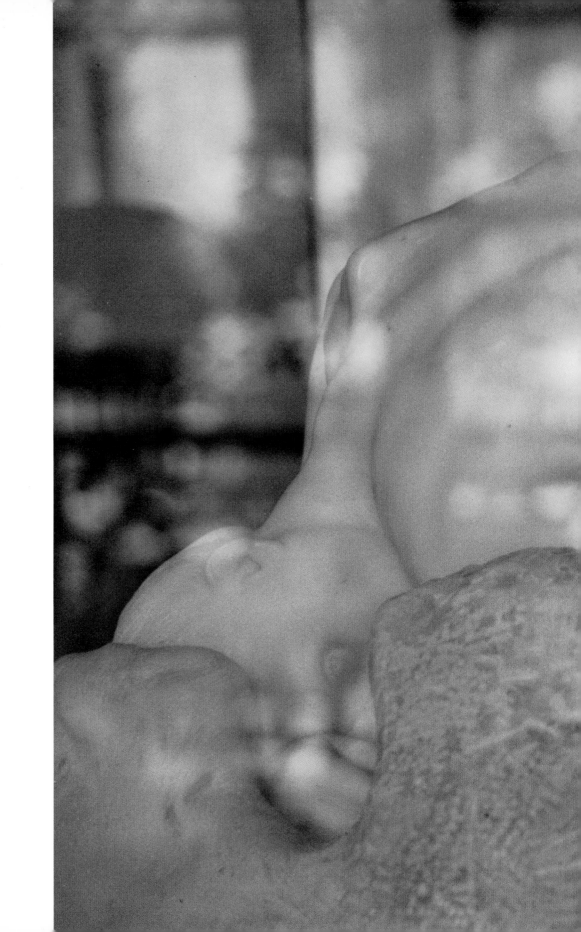

DANAID
1889, marble

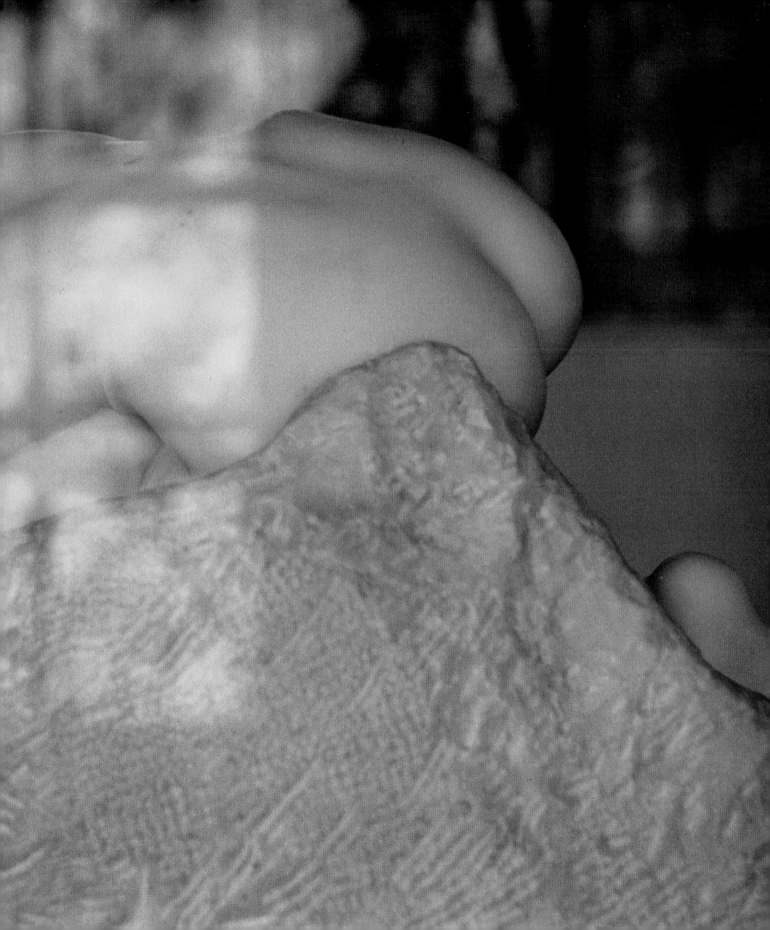

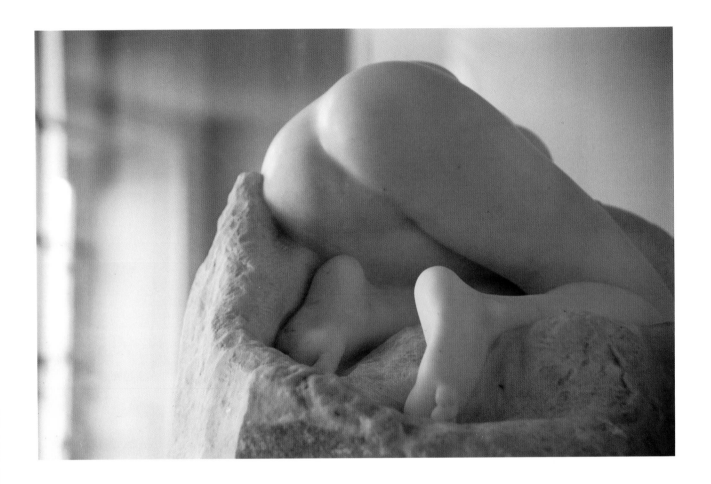

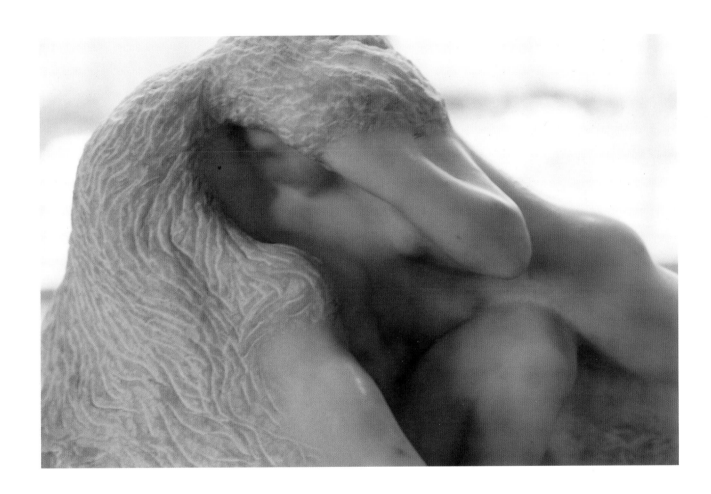

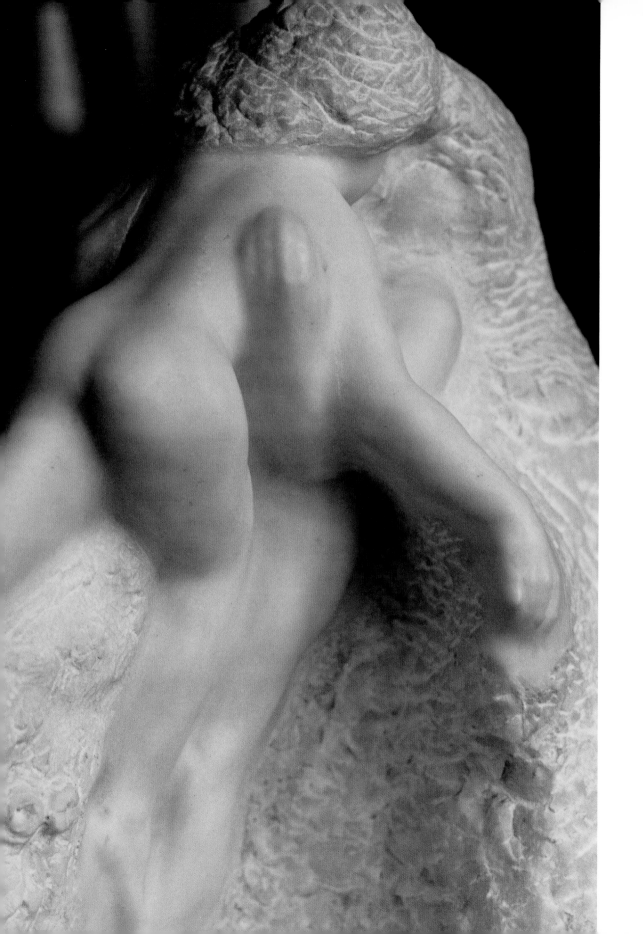

NYMPHS PLAYING
c. 1900, *marble*

'...CLOUDS DISSOLVE INTO WHITE PLUMES,
JOYOUS, FORMED OF A THOUSAND INVISIBLE CURRENTS.
SO THOUGHT, ACHIEVING MATURITY, BURSTS INTO LIGHT WHILE ITS ORIGINS
REMAIN UNKNOWN. CLOUDS CHANGE, LIKE CONVERSATIONS
BETWEEN AGILE AND FREE MINDS.'

Auguste Rodin, *Cathedrals of France*

THE TEMPEST
c. 1886, marble

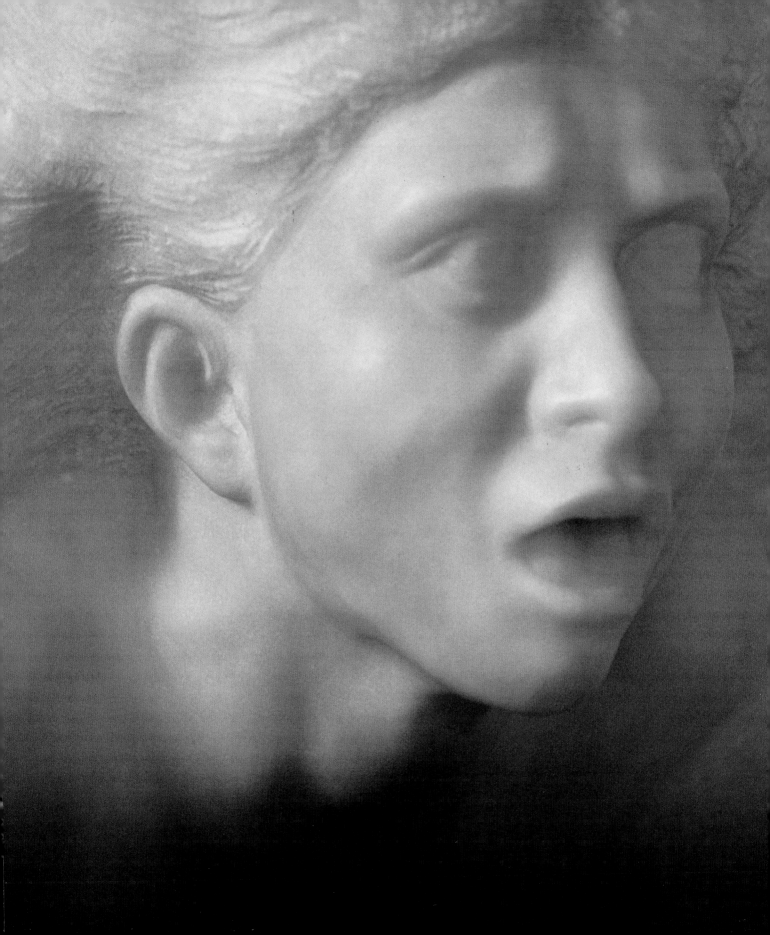

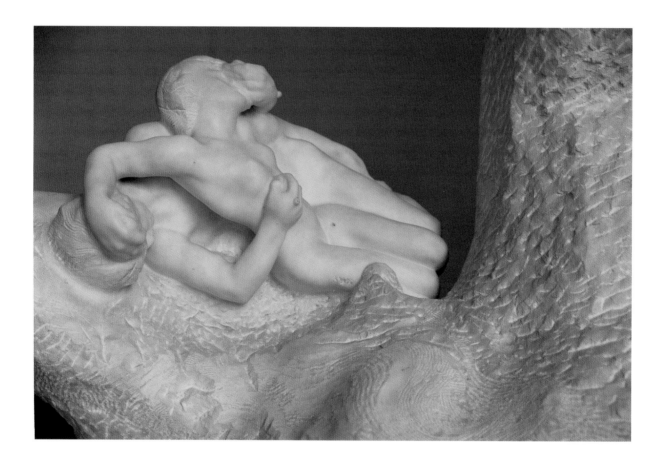

'LIGHT SERVES, IN CONFORMITY WITH DEPRESSIONS AND RELIEFS,
TO GIVE THE EYE THE SAME SENSATION THAT THE HAND RECEIVES FROM TOUCH.'

Auguste Rodin, from *Rodin: The Man and His Art, with Leaves from His Notebook* by J. Cladel

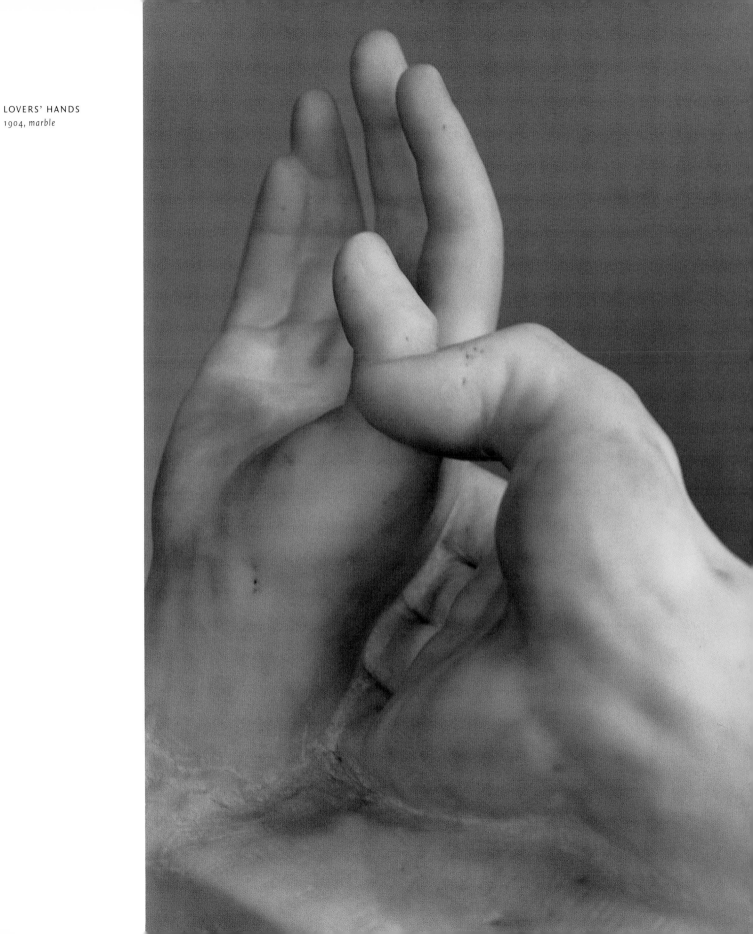

LOVERS' HANDS
1904, marble

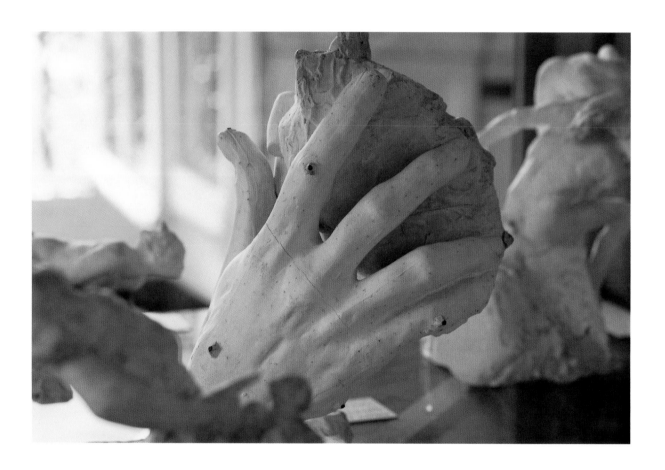

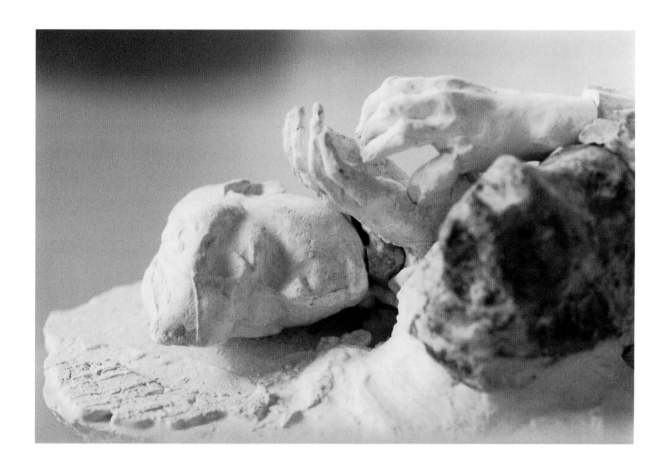

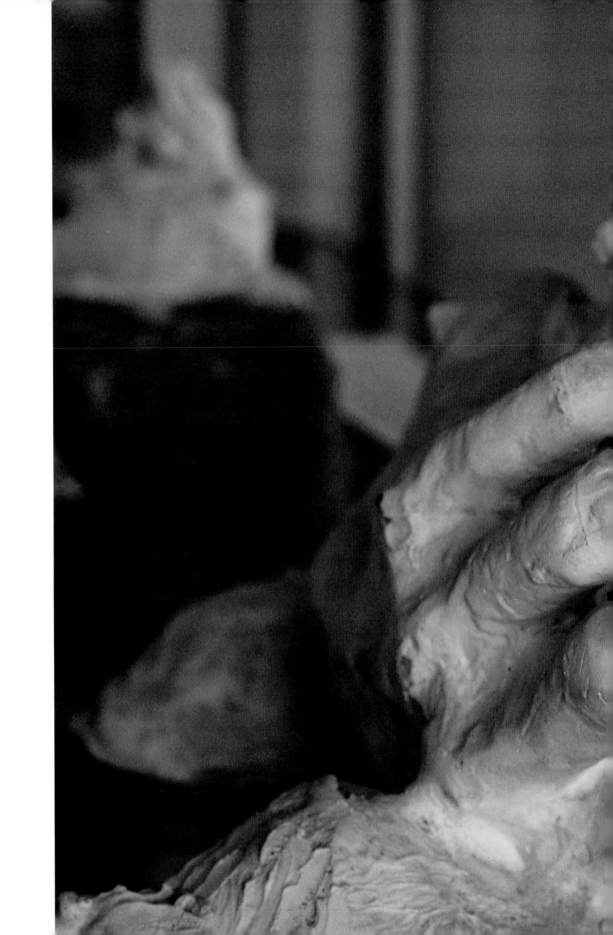

THE DEVIL'S HAND
c. 1902, *plaster*

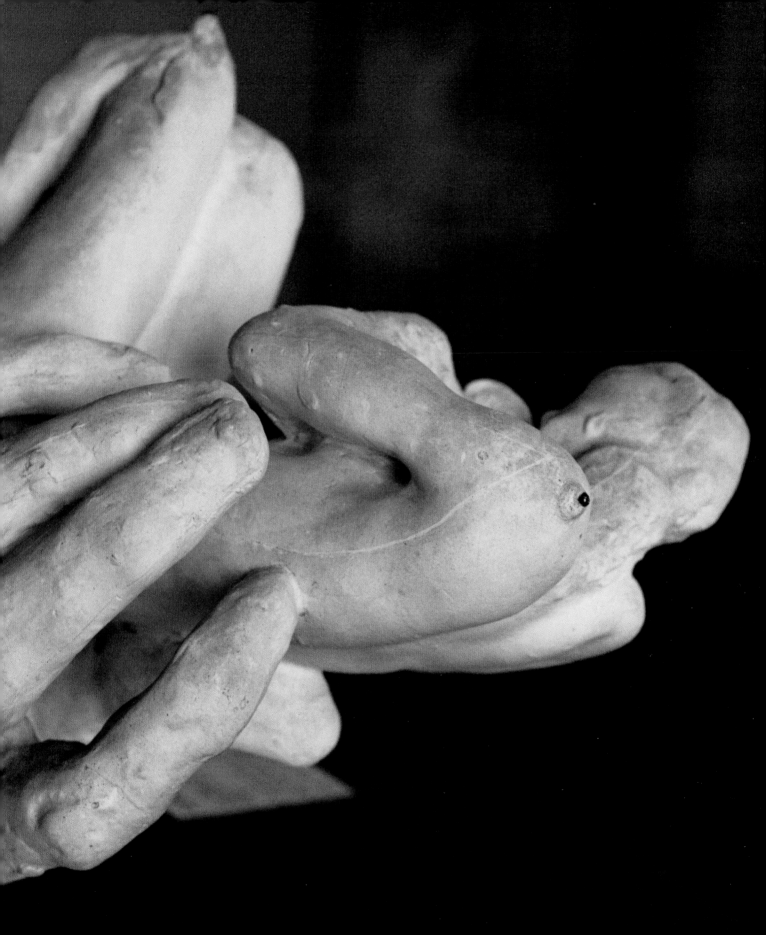

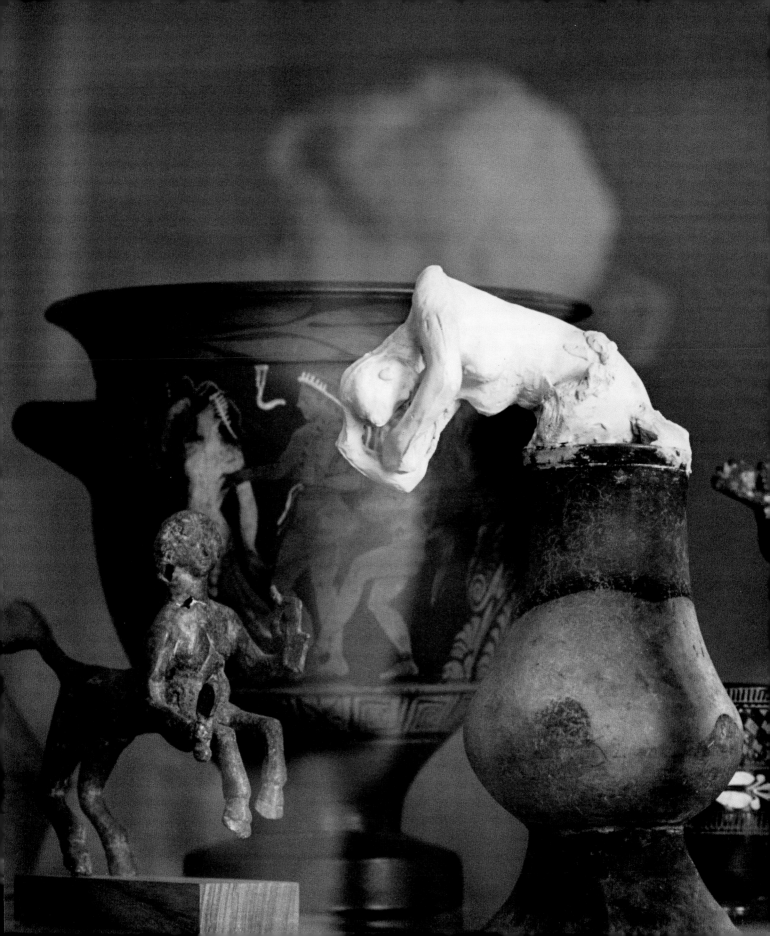

OLD MAN SITTING IN A VASE
No date, terracotta and pottery

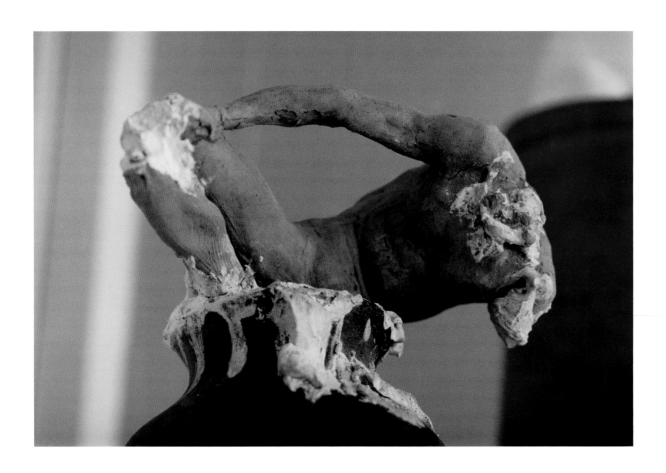

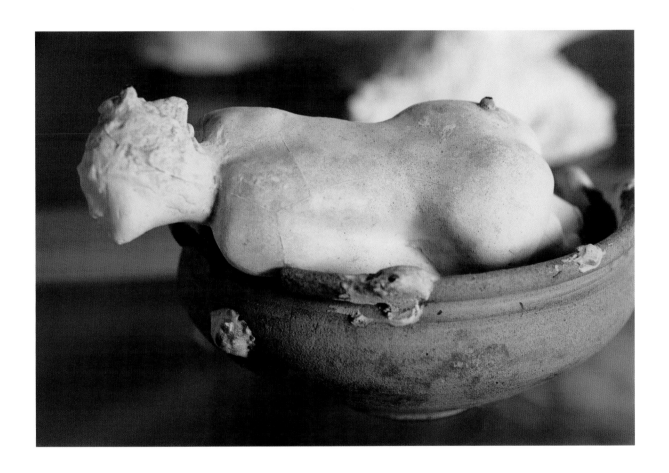

'SO AT HOME I HAVE FRAGMENTS OF GODS FOR MY DAILY ENJOYMENT...

THESE MARBLES MORE THAN TWO THOUSAND YEARS OLD, TALK TO ME LOUDER,

AND MOVE ME MORE THAN LIVING BEINGS...

THE ANTIQUE AND NATURE ARE LINKED BY THE SAME MYSTERY.'

Auguste Rodin, from *Rodin: Antiquity Is My Youth* by B. Garnier

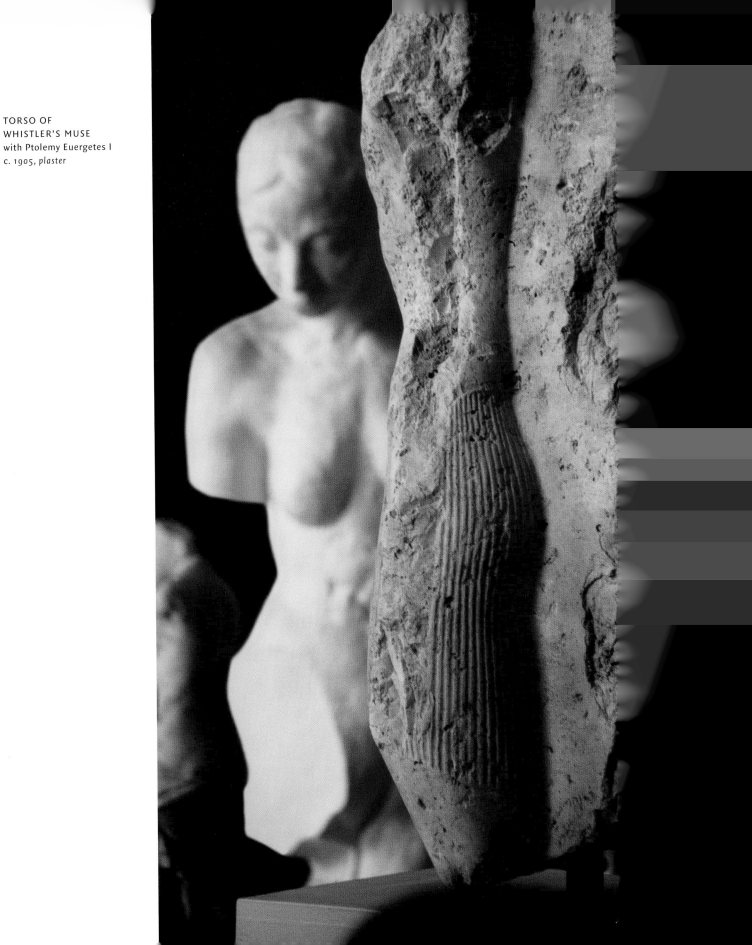

TORSO OF
WHISTLER'S MUSE
with Ptolemy Euergetes I
c. 1905, *plaster*

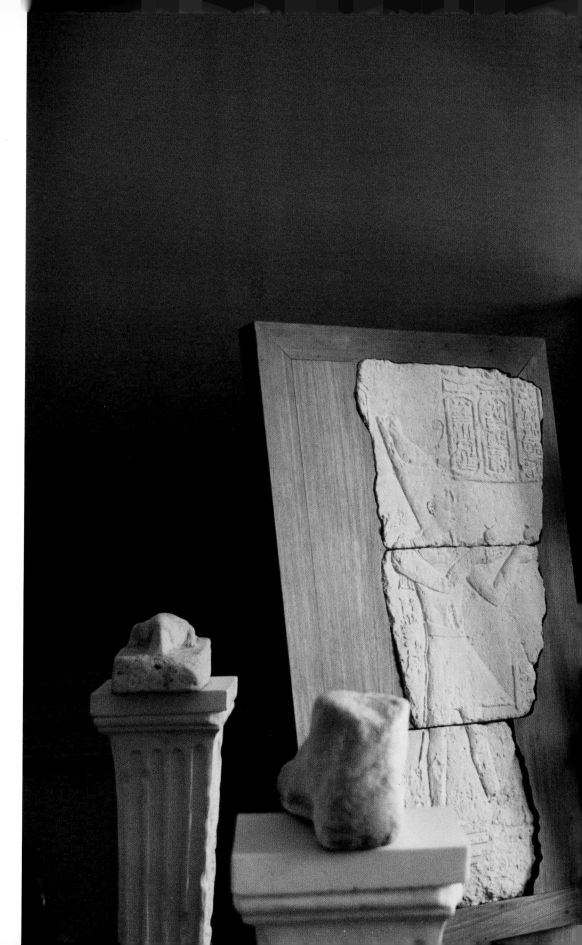

TORSO OF
WHISTLER'S MUSE
with antiquities
c. 1905, *plaster*

'IT IS TRUE THAT SIMPLICITY IS DIFFICULT TO ATTAIN;
ALL THAT WE ARE, ALL THAT WE DO, IS IN RELATIONSHIP WITH NATURE AS A WHOLE.
THUS IT IS OF NATURE AS A WHOLE THAT ONE MUST ALWAYS THINK.
IS THAT POSSIBLE? BUT NATURE AS A WHOLE IS NEVERTHELESS THERE,
BEFORE ME IN THE MODEL, A TRUE POINT OR A MULTITUDE OF TRUE POINTS.
LET US OBSERVE THE MODEL ATTENTIVELY, IT WILL TELL US ALL.'

Auguste Rodin, *Cathedrals of France*

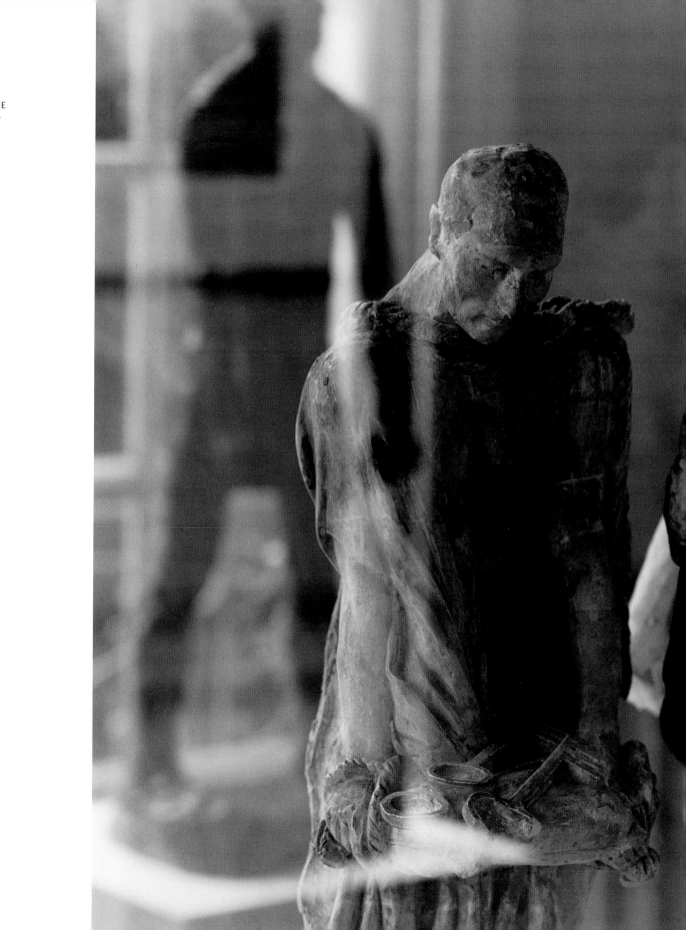

JEAN D'AIRE
1885, plaster

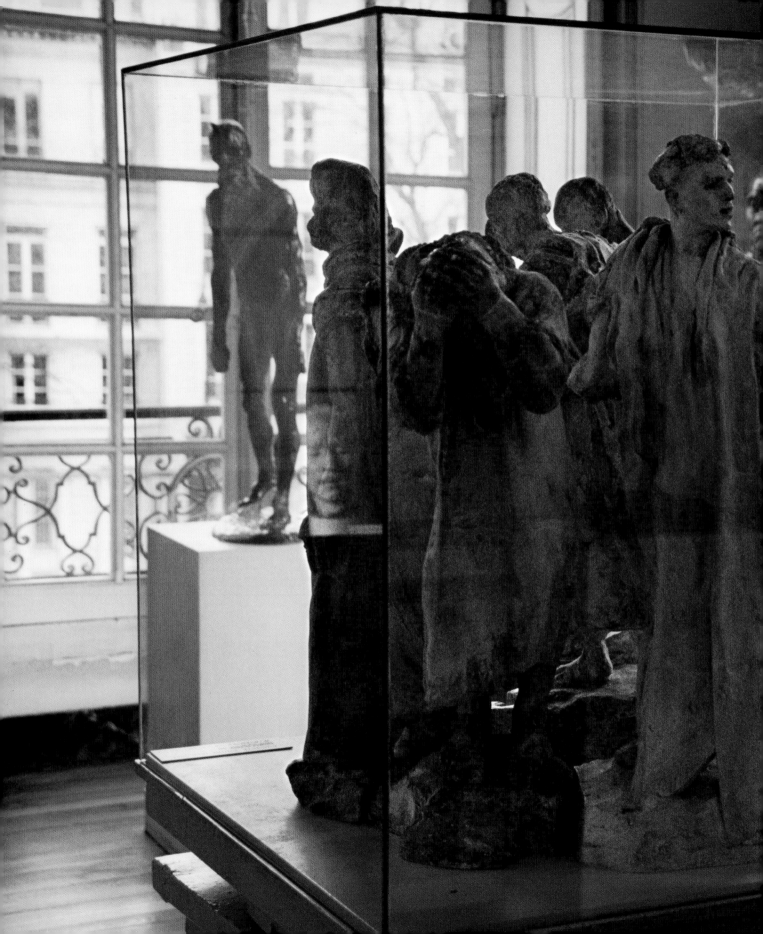

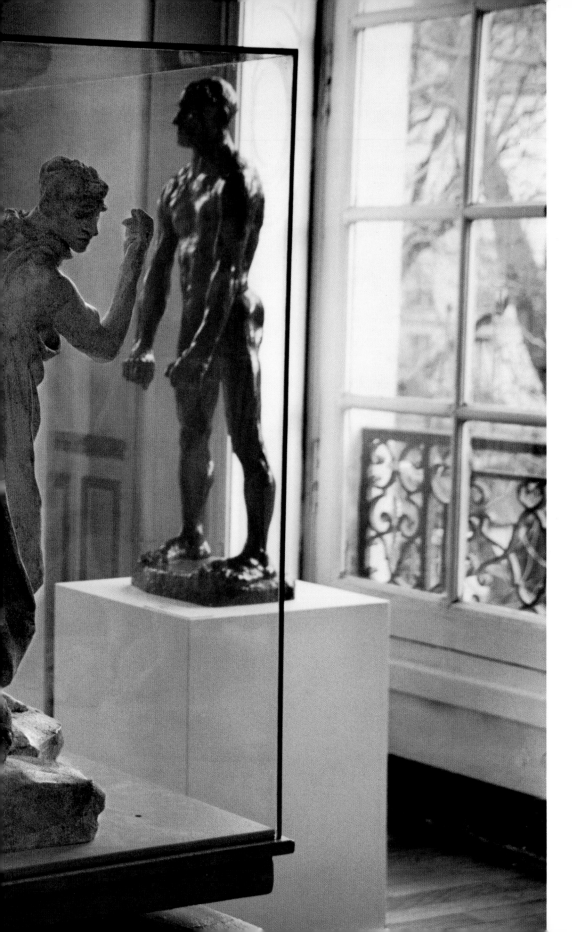

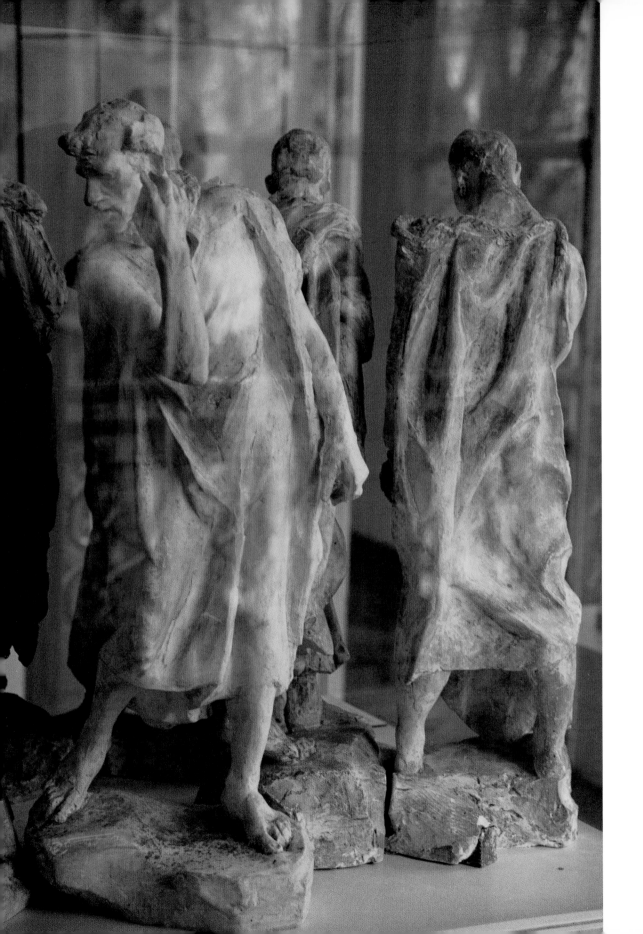

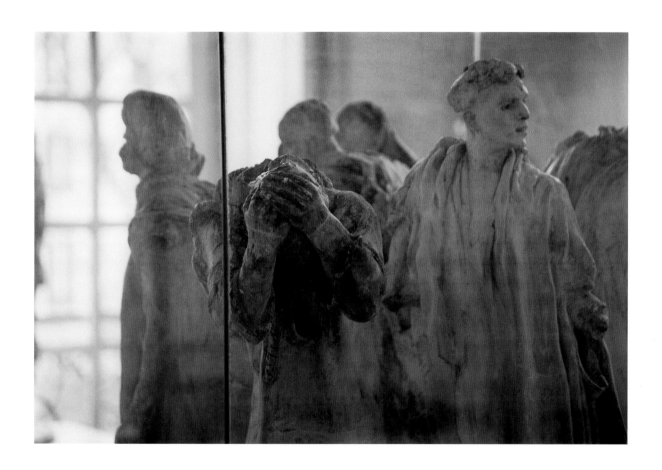

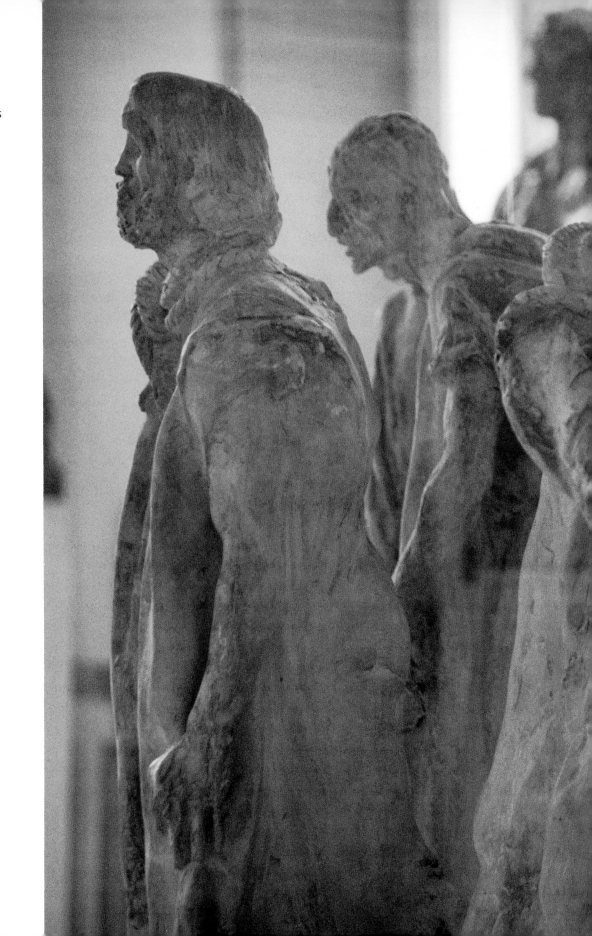

THE BURGHERS OF CALAIS
1885, plaster

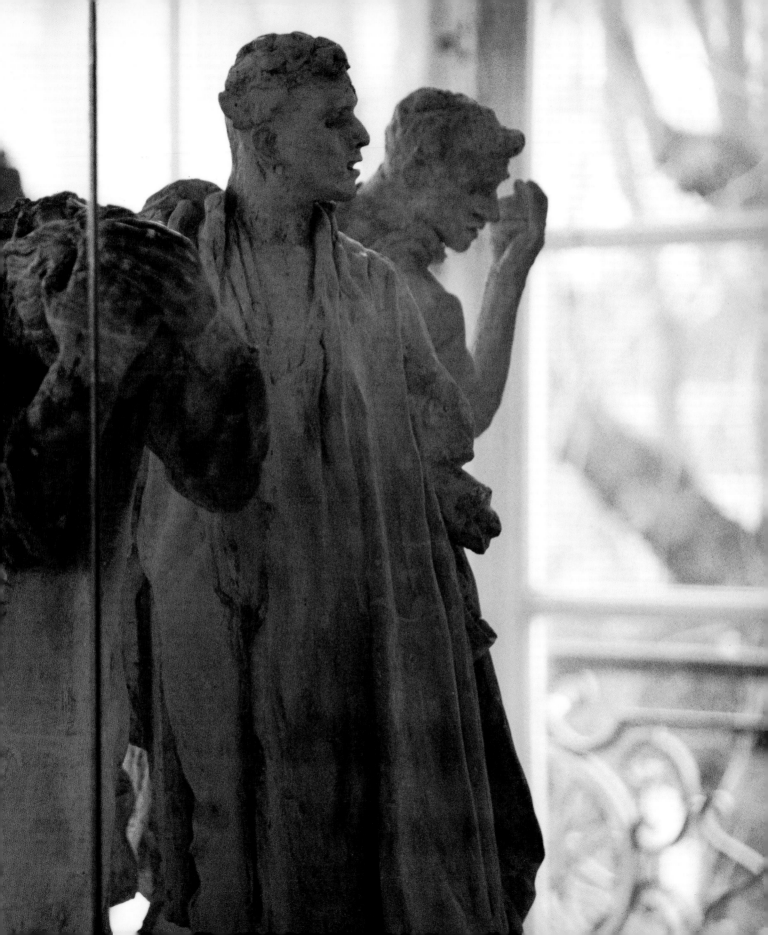

'FEMININE CHARM WHICH CRUSHES OUR DESTINY,
MYSTERIOUS FEMININE POWER THAT RETARDS THE THINKER,
THE WORKER AND THE ARTIST,
WHILE AT THE SAME TIME IT INSPIRES THEM – A COMPENSATION
FOR THOSE WHO PLAY WITH FIRE.'

Auguste Rodin, from *Rodin: The Man and His Art, with Leaves from His Notebook* by J. Cladel

ASSEMBLAGE:
FEMALE NUDE
STANDING IN A VASE
No date
Plaster and terracotta

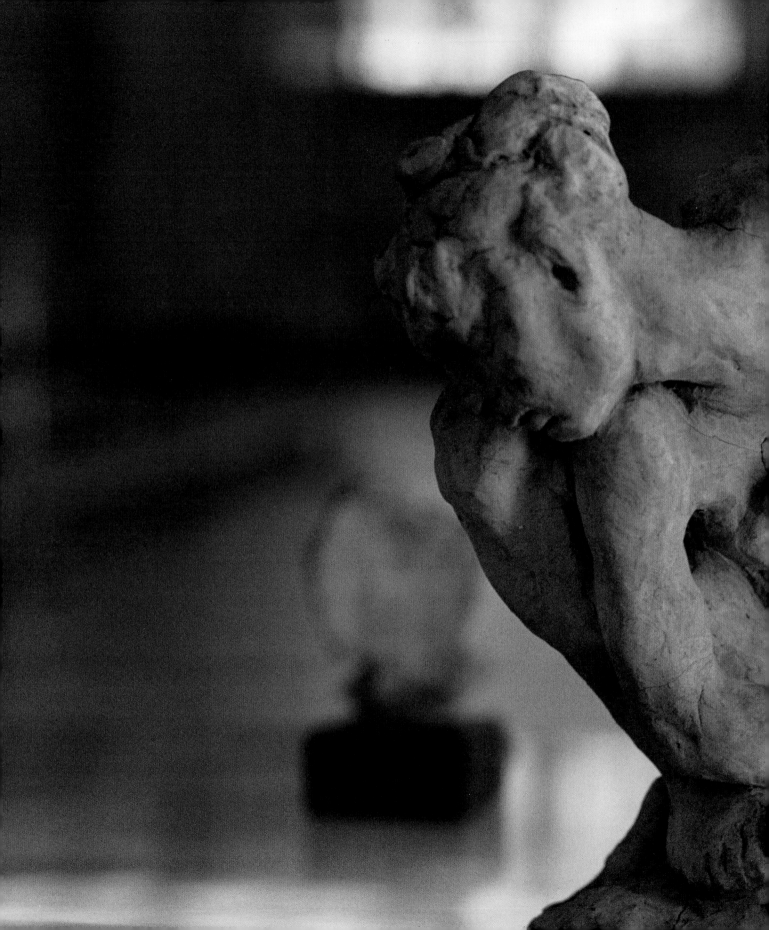

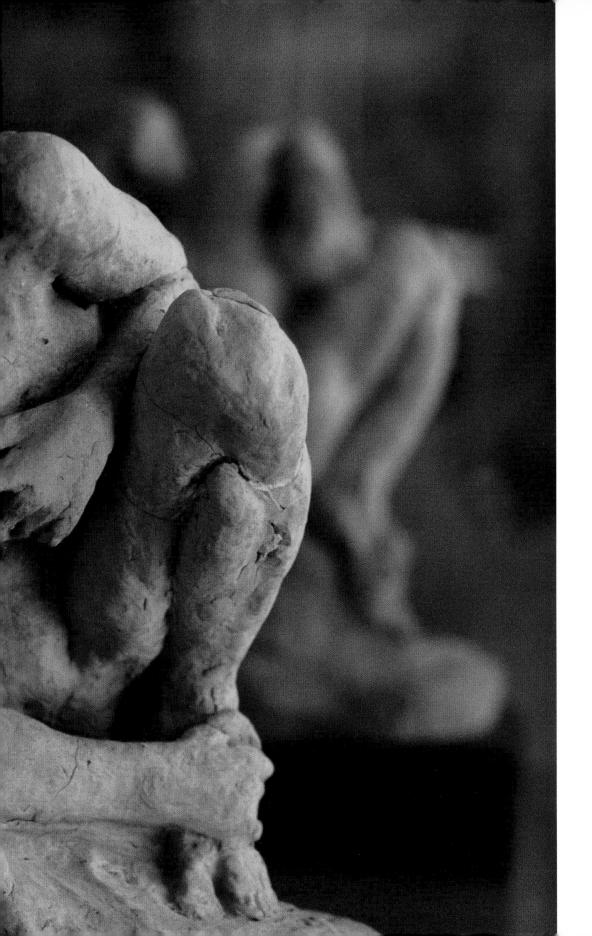

THE CROUCHING WOMAN
1882, terracotta

I AM BEAUTIFUL
c. 1885, plaster

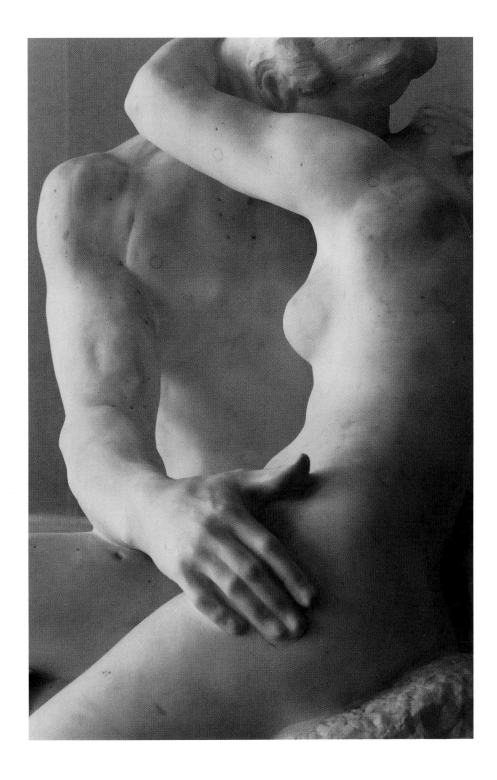

ASSEMBLAGE: TWO EVES AND THE CROUCHING WOMAN
1905–6, plaster

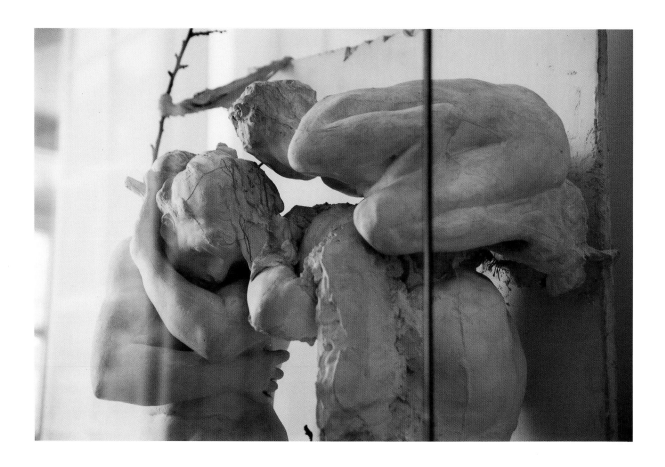

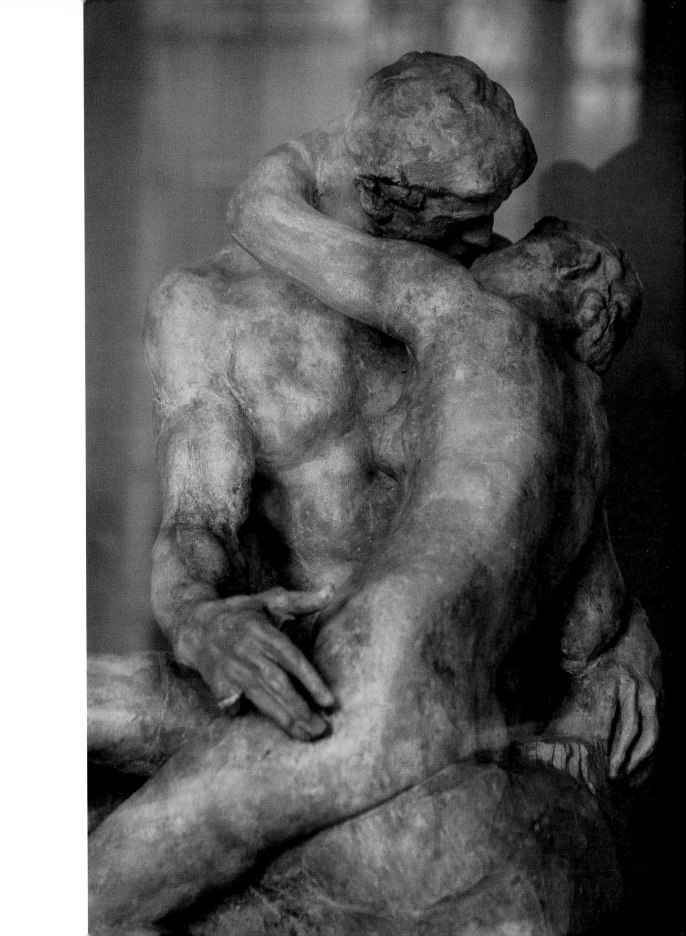

THE KISS
1882, terracotta

'FROM MY PRESENT POINT OF VIEW,
THE SKY IS THE MOST IMPORTANT LANDSCAPE,
THE SKY REIGNS OVER ALL THINGS,
FOREVER CHANGING THEIR ASPECT AND MAKING NEW SPECTACLES
OF THE MOST FAMILIAR SIGHTS.'

Auguste Rodin, *Cathedrals of France*

MONUMENT TO
VICTOR HUGO
No date, plaster

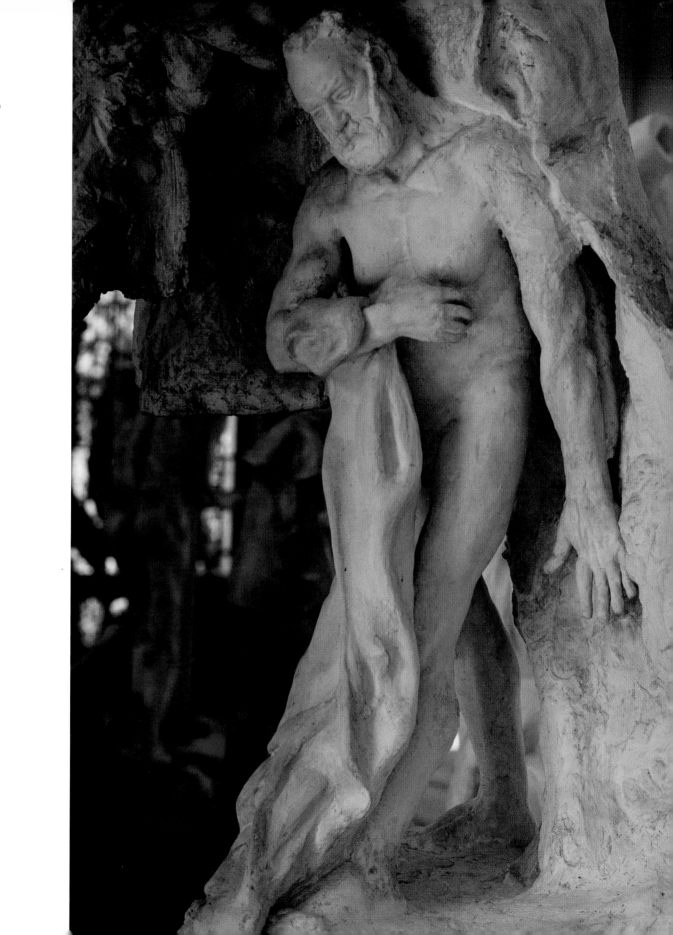

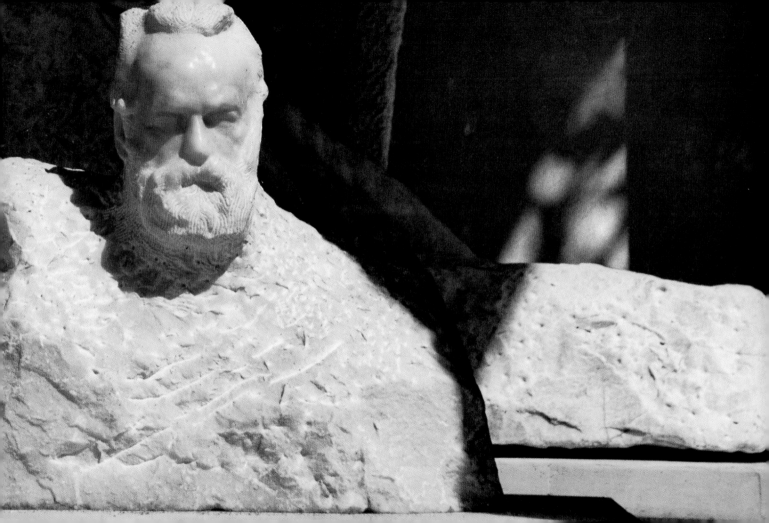

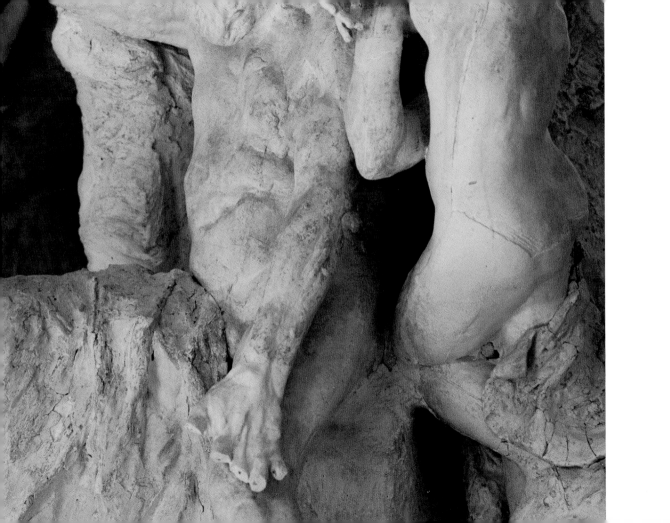

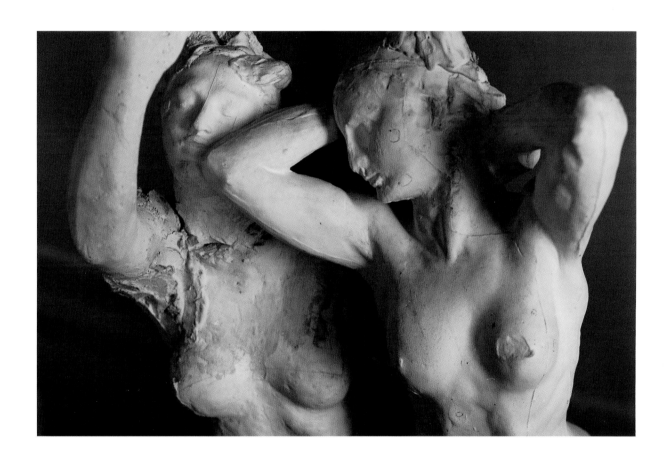

BALZAC, NUDE STUDY C
1892, plaster

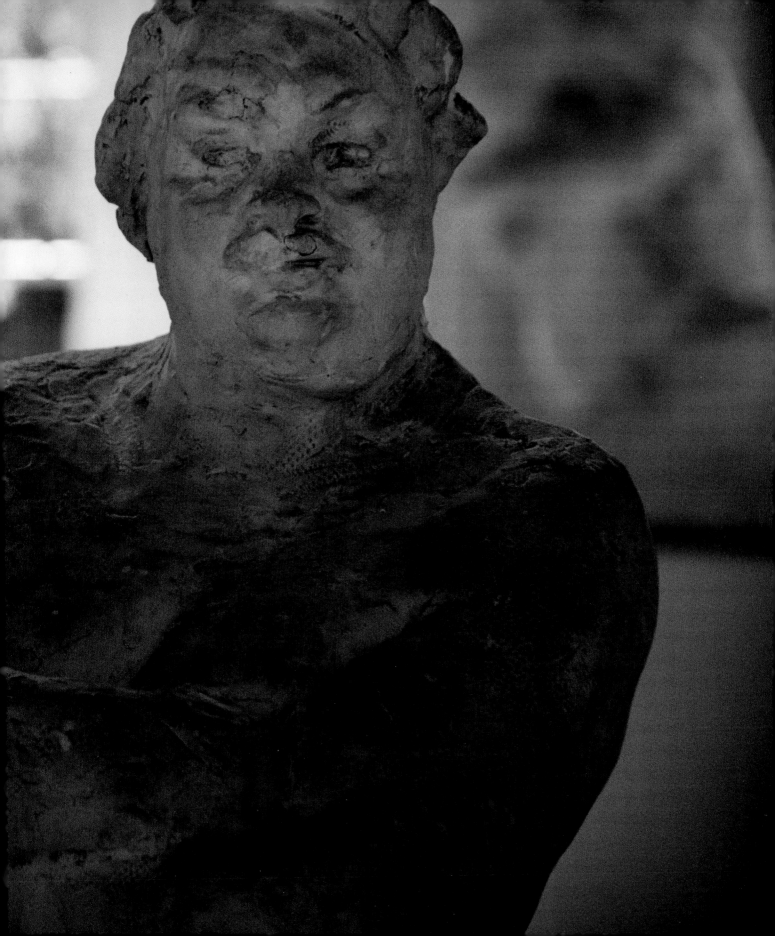

'WE ARE TAUGHT THINGS AS IF THEY WERE DIVIDED,

AND MAN LEAVES THEM DIVIDED.

RARE ARE THOSE WHO CONSENT TO THE PATIENT EFFORT REQUIRED TO REASSEMBLE THEM.

THE SECRET OF A GOOD DRAWING IS IN THE SENSE OF ITS CONCORDANCES:

THINGS LAUNCH INTO EACH OTHER,

INTERPENETRATE AND CLARIFY ONE ANOTHER MUTUALLY.

THIS IS LIFE'S WAY.'

Auguste Rodin, *Cathedrals of France*

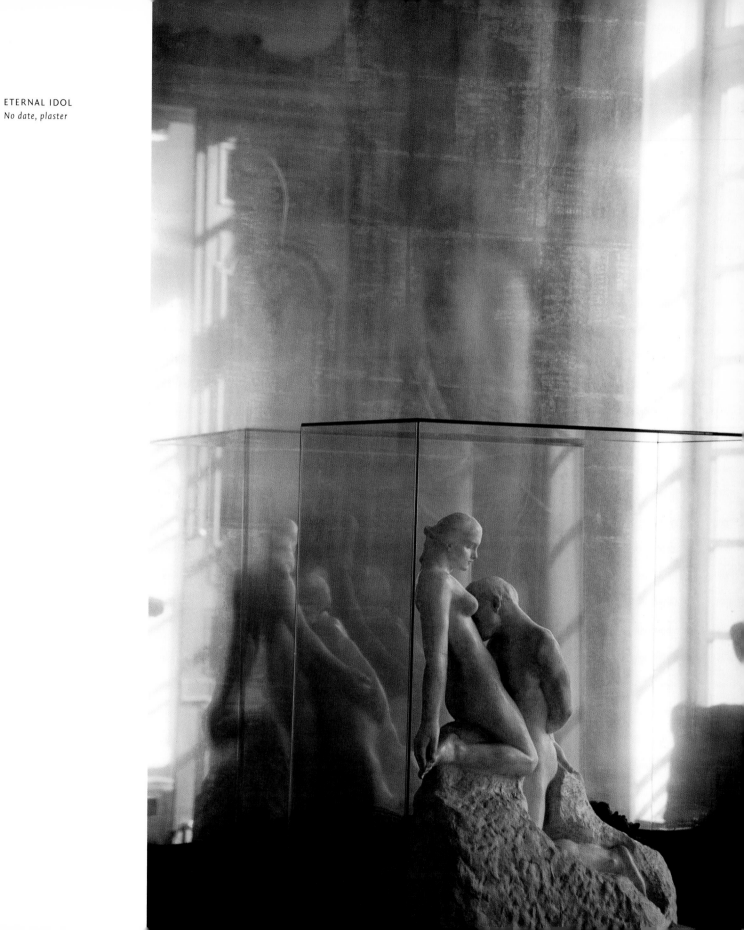

ETERNAL IDOL
No date, plaster

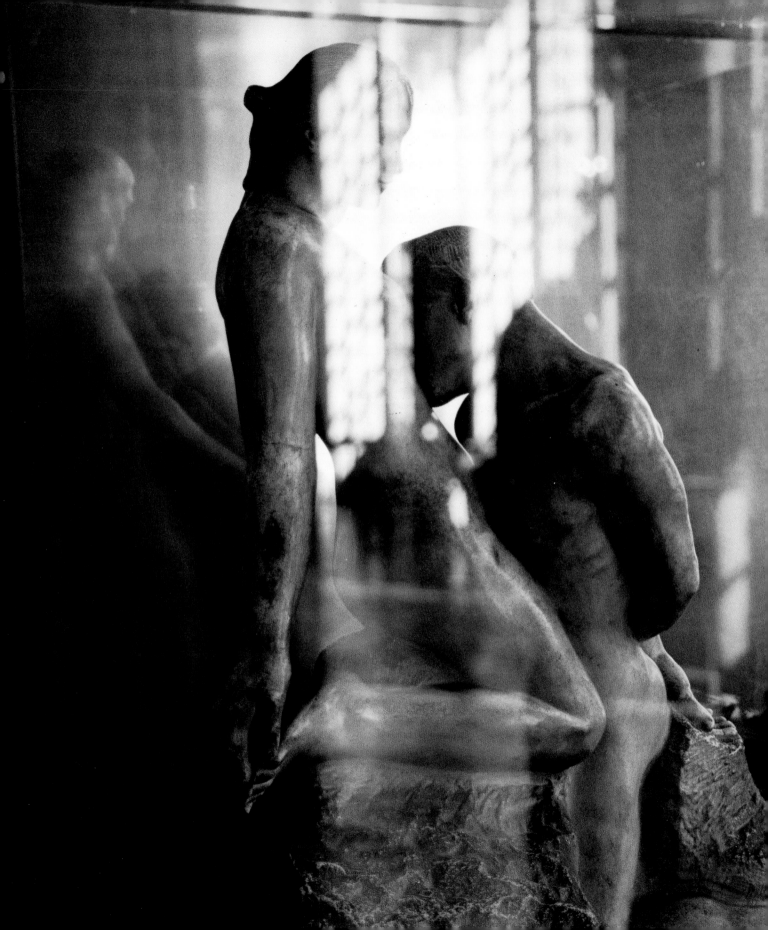

ETERNAL IDOL
No date, plaster

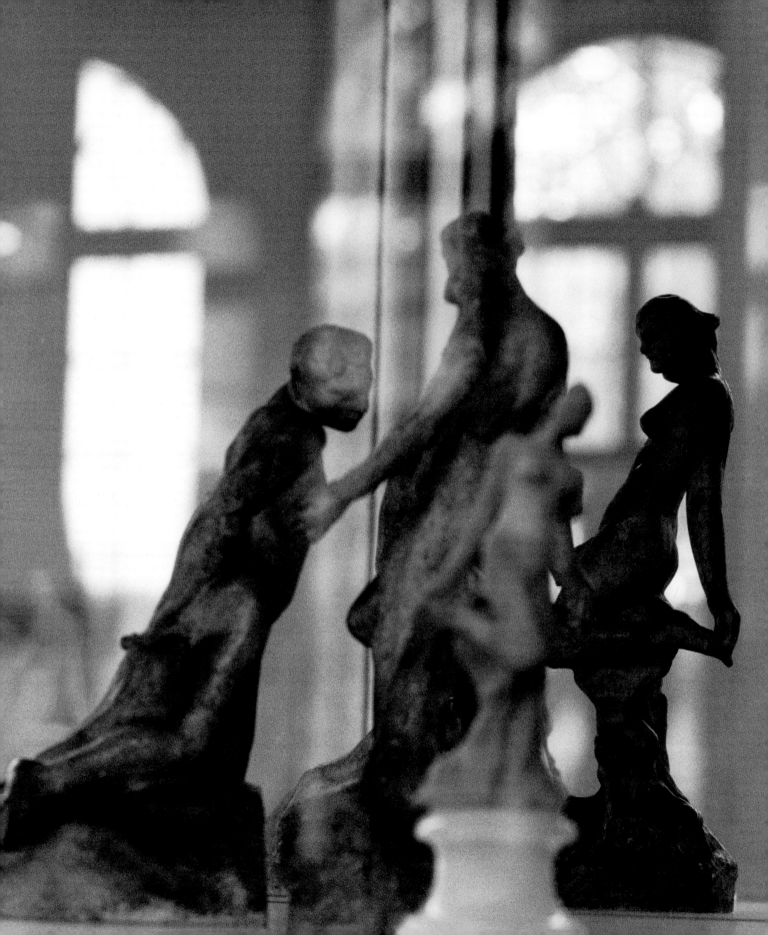

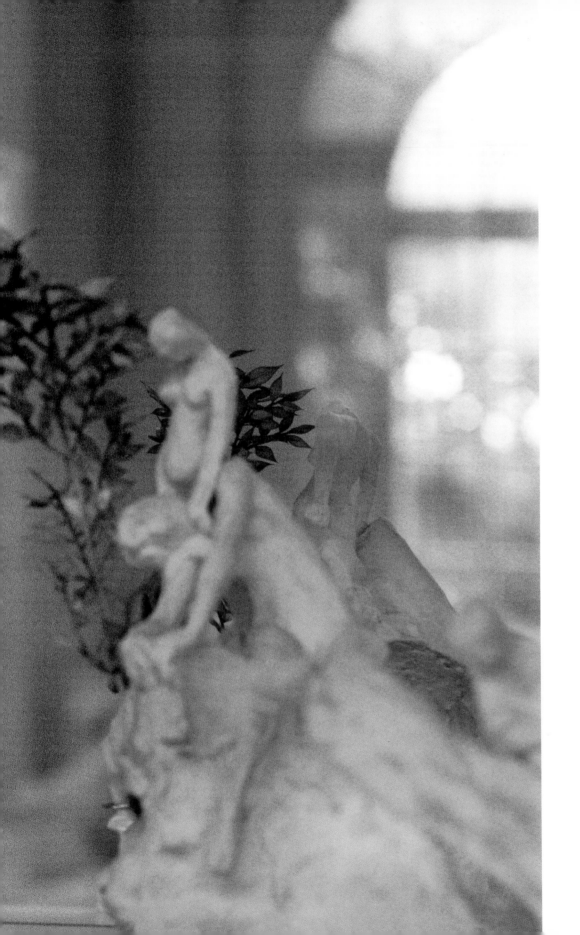

STUDIES FOR THE ETERNAL IDOL
Plaster and terracotta

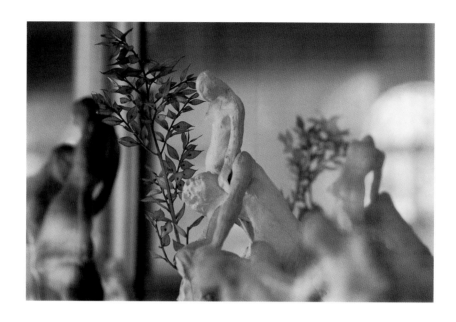

ASSEMBLAGE: WOMAN DAMNED AND MALE NUDE
No date, plaster

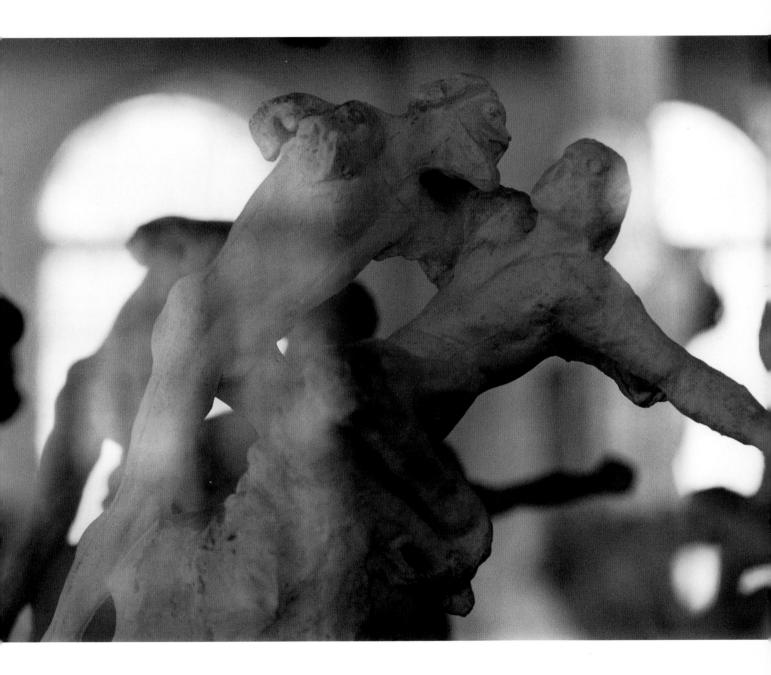

ASSEMBLAGE: WOMAN DAMNED AND MALE NUDE
No date, plaster

WOMAN DAMNED
No date, plaster

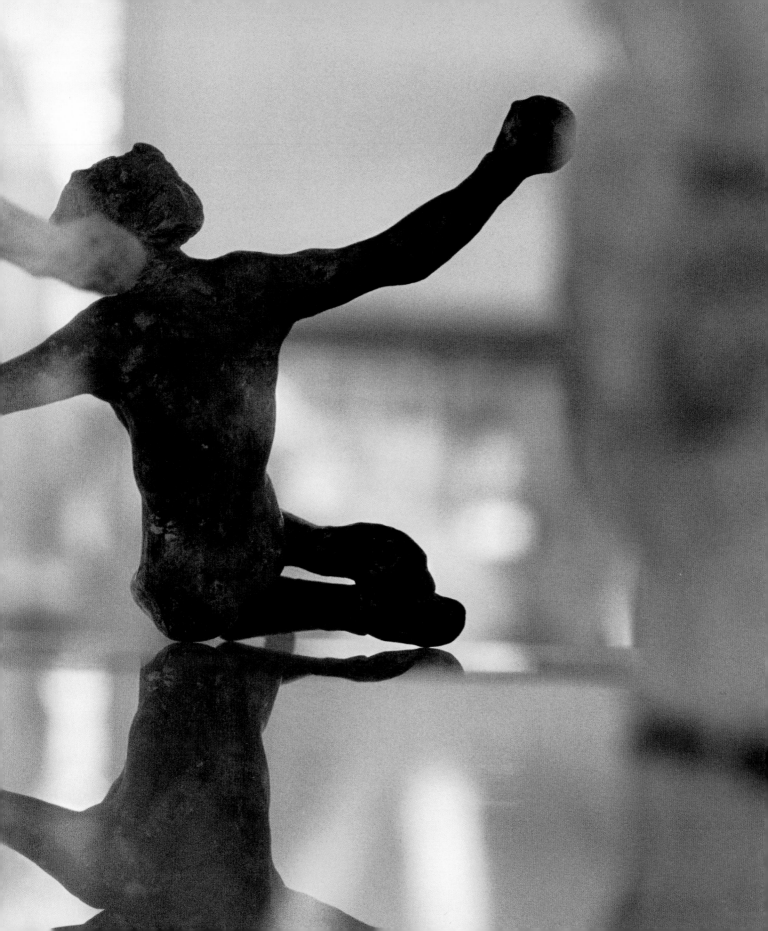

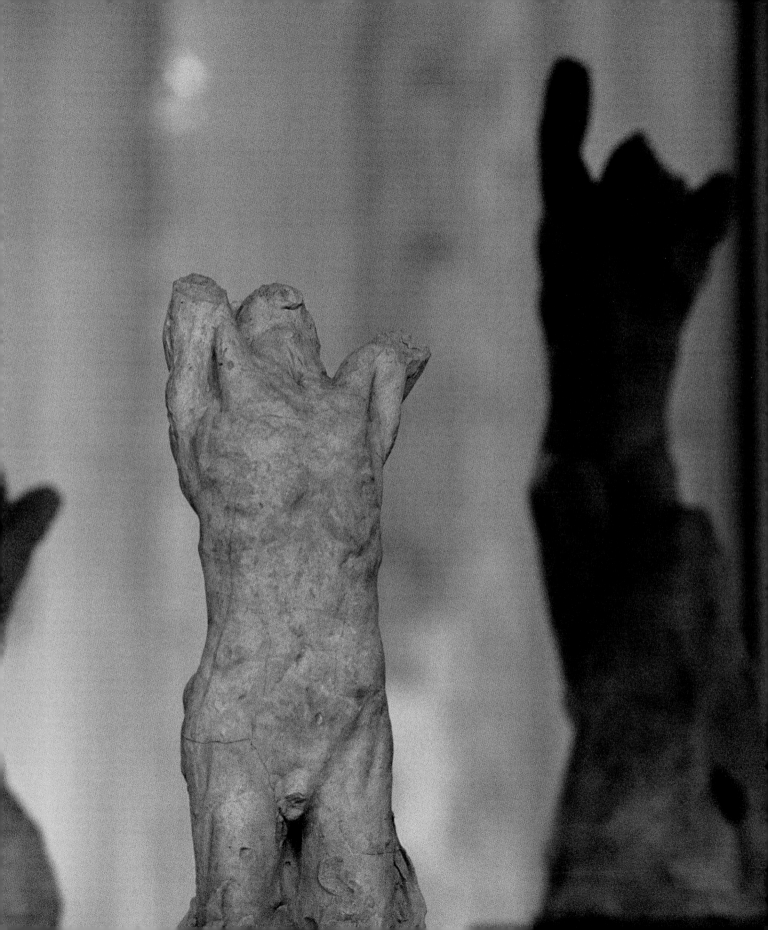

'WHAT IS BEAUTIFUL IN LANDSCAPE IS ALSO BEAUTIFUL IN ARCHITECTURE.
IT IS THE AIR, WHICH NO ONE APPRECIATES: IT IS DEPTH.
DEPTH SEDUCES THE SOUL AND SENDS IT WHERE IT WILL.'

Auguste Rodin, *Cathedrals of France*

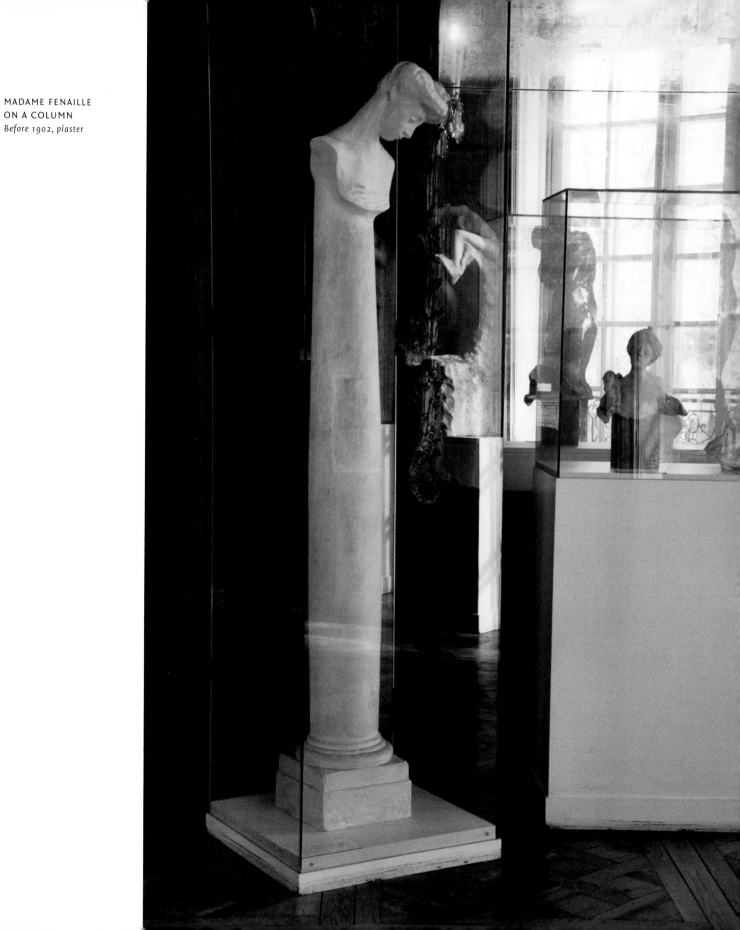

MADAME FENAILLE
ON A COLUMN
Before 1902, plaster

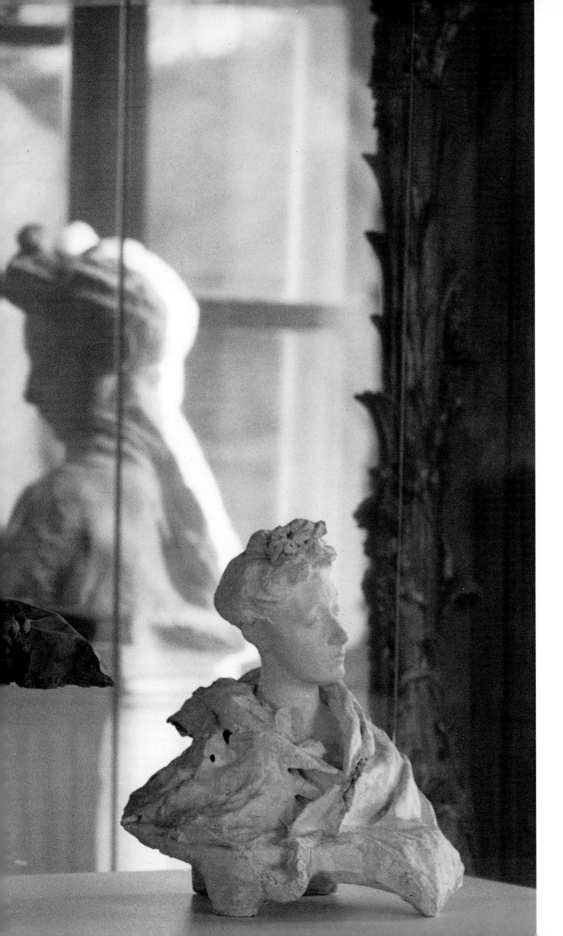

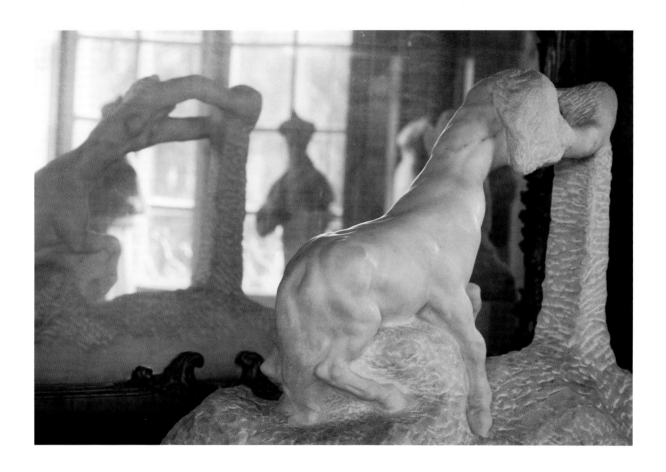

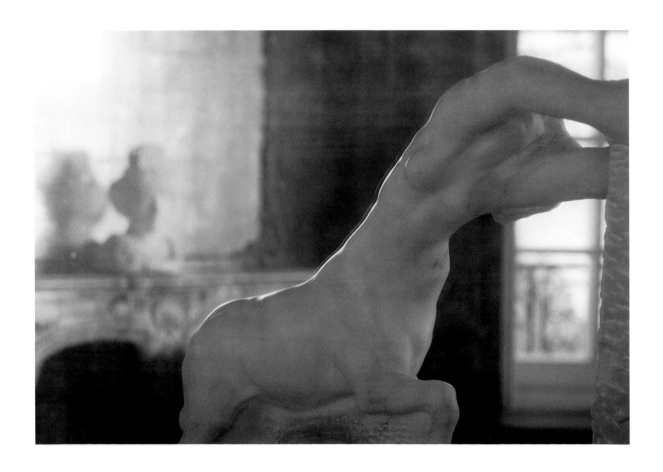

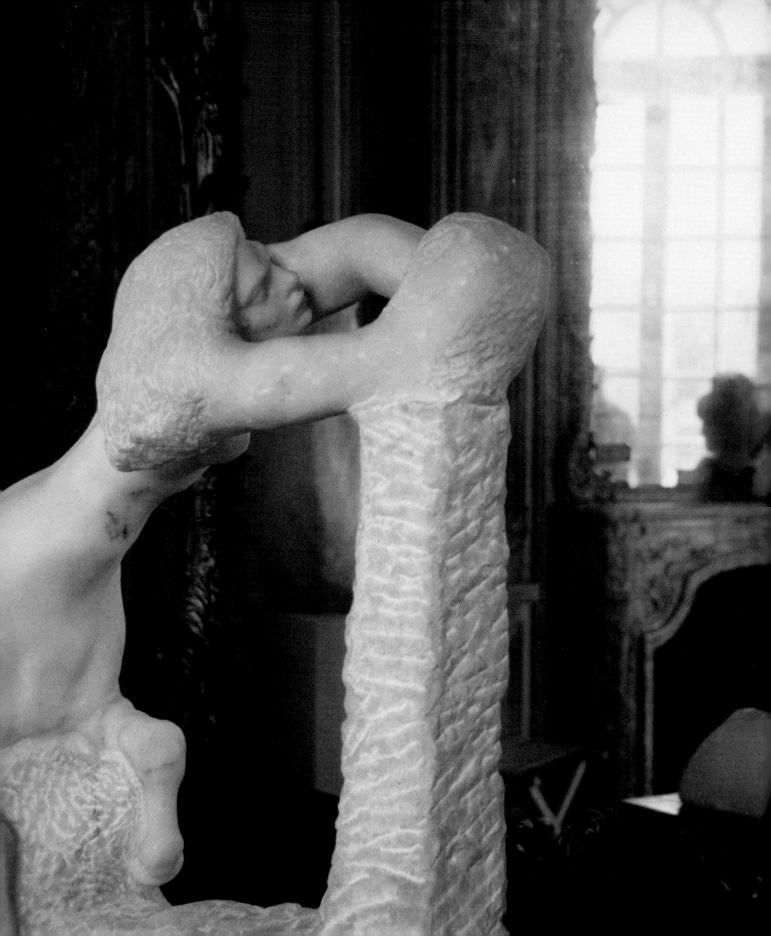

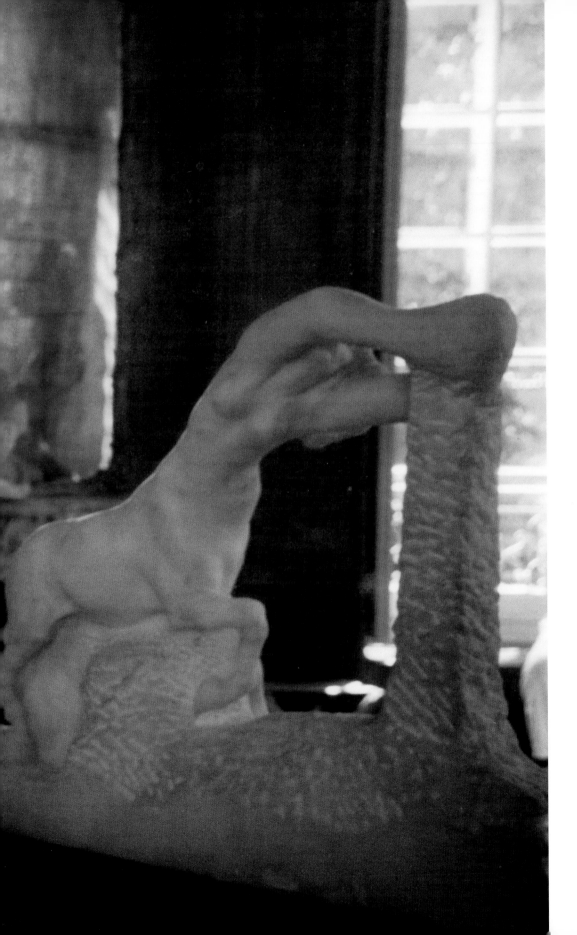

THE CENTAURESS
1901–4, marble

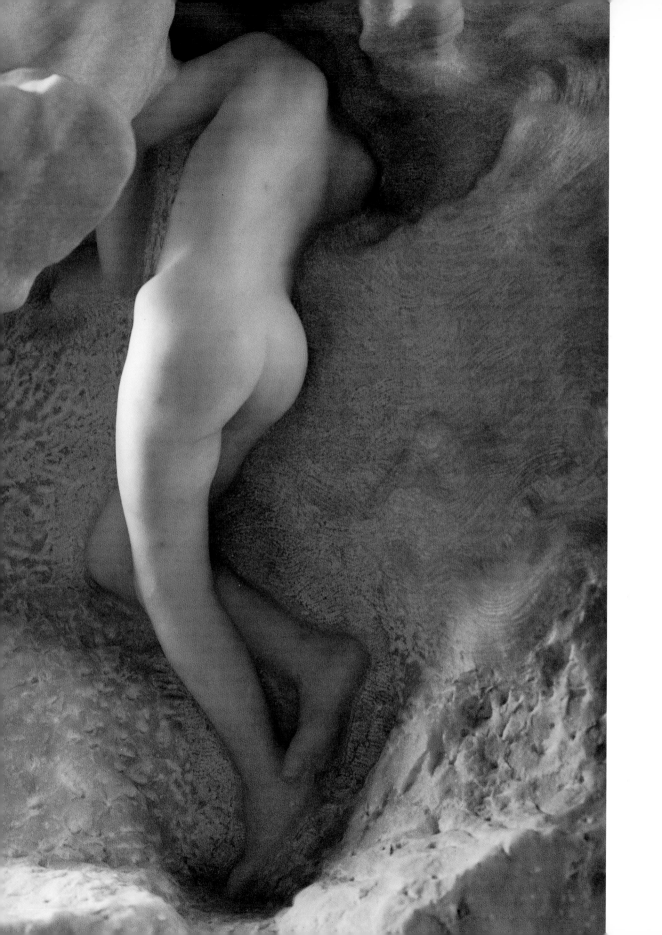

THE EARTH AND
THE MOON
1899, marble

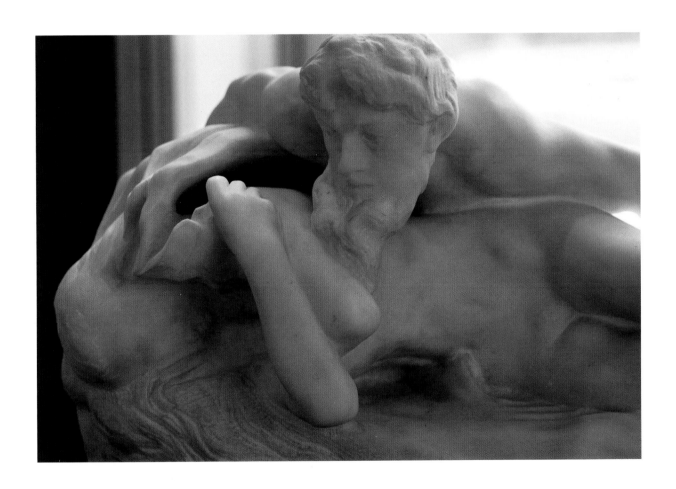

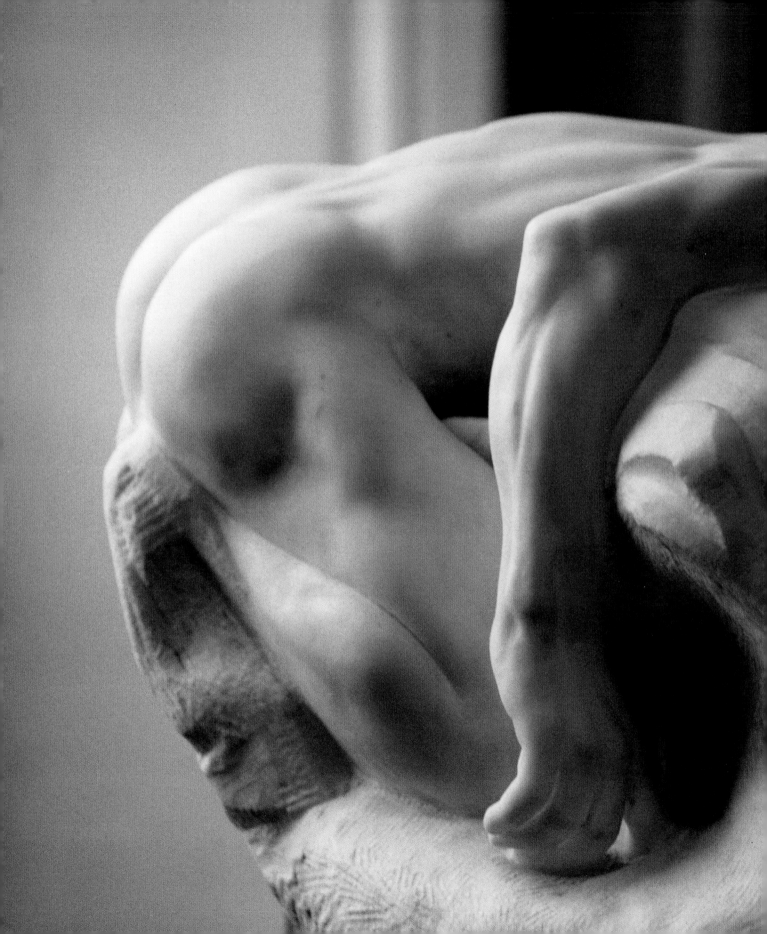

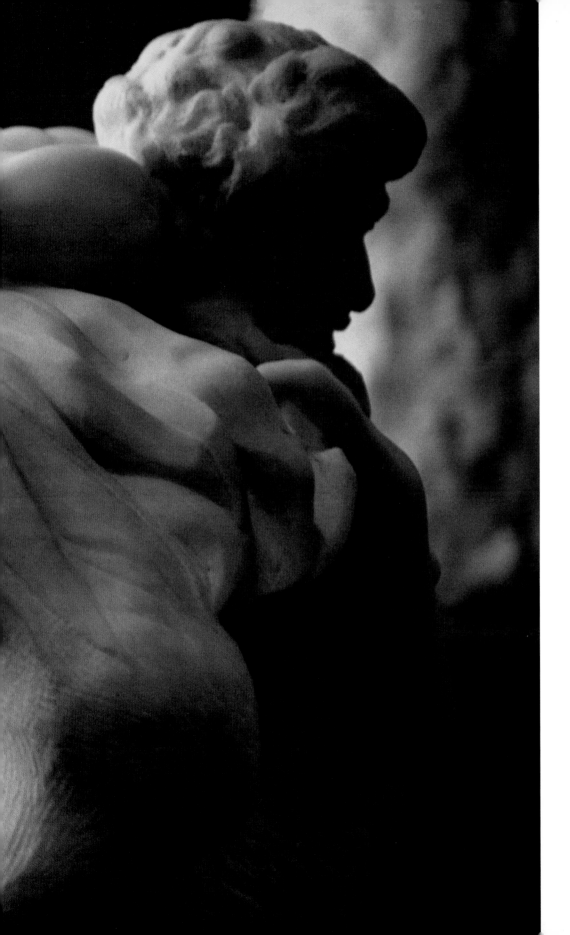

SPRING-PSYCHE
1889, marble

'THERE ARE MANY WAYS OF SEEING A BEAUTIFUL THING.

AS NEW PROFILES APPEAR WHEN ONE MOVES,

SO A MASTERPIECE IS TRANSFORMED IN US

ACCORDING TO THE MOVEMENT IT HAS PROVOKED IN OUR MIND;

THIS MOVEMENT, WHICH IS NOT ISOLATED IN OUR LIFE,

ADDS TO ALL OUR FEELINGS THE IMPRESSION OF THE MASTERPIECE THAT WE KEEP,

AND THIS IMPRESSION LIVES BY OUR LIFE,

IS COLOURED ACCORDING TO OTHER IMPRESSIONS THAT LIFE BRINGS US,

AND THANKS TO WHICH WE DISCOVER,

BETWEEN TWO EXPRESSIONS VERY DISTANT ONE FROM THE OTHER,

SECRET BUT REAL ANALOGIES.'

Auguste Rodin, *Cathedrals of France*

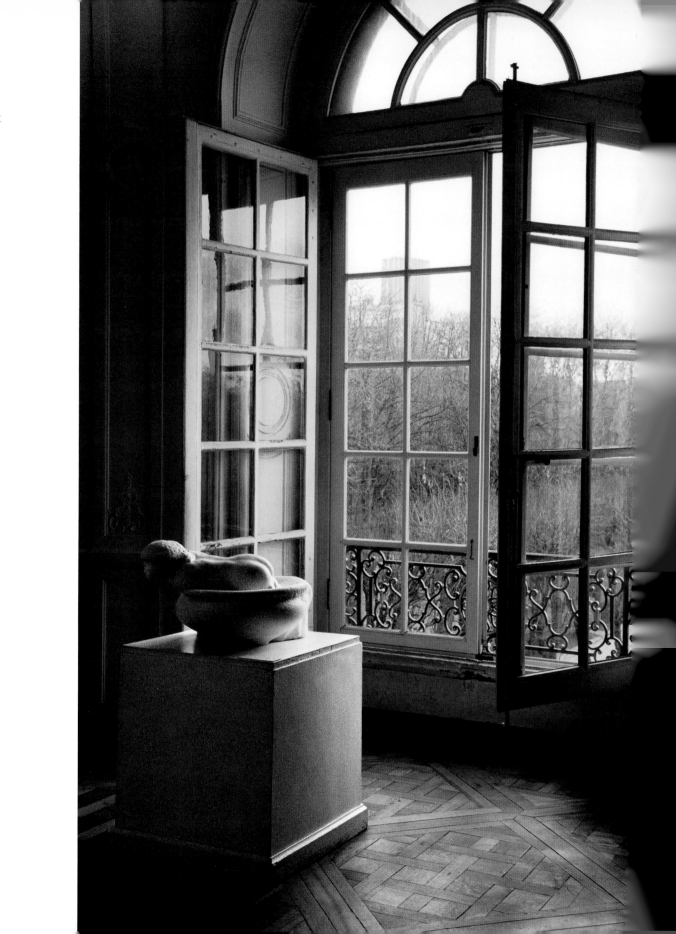

THE LITTLE
WATER SPRITE
1903, marble

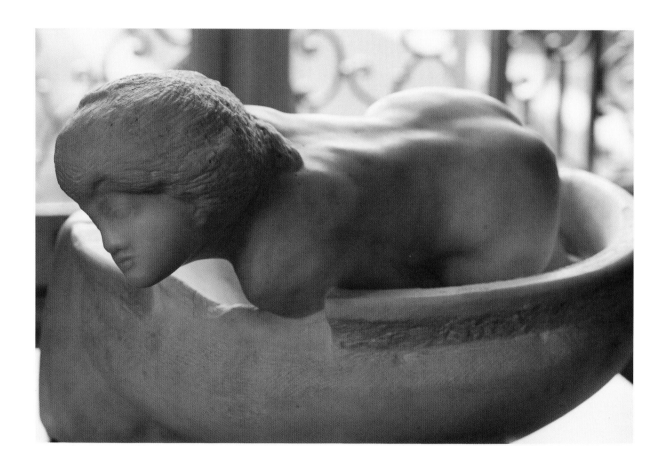

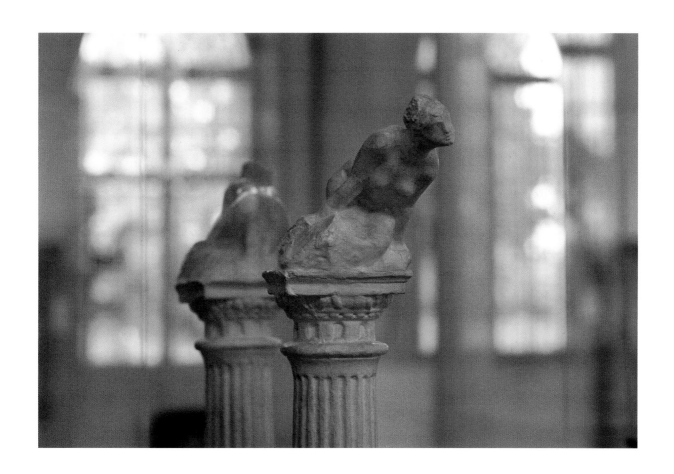

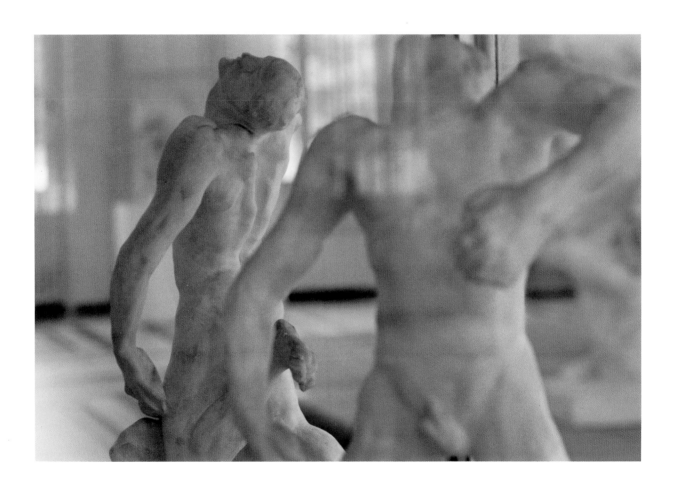

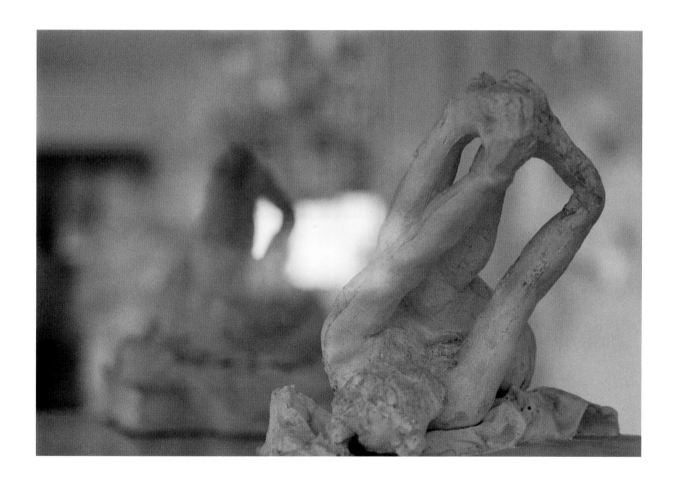

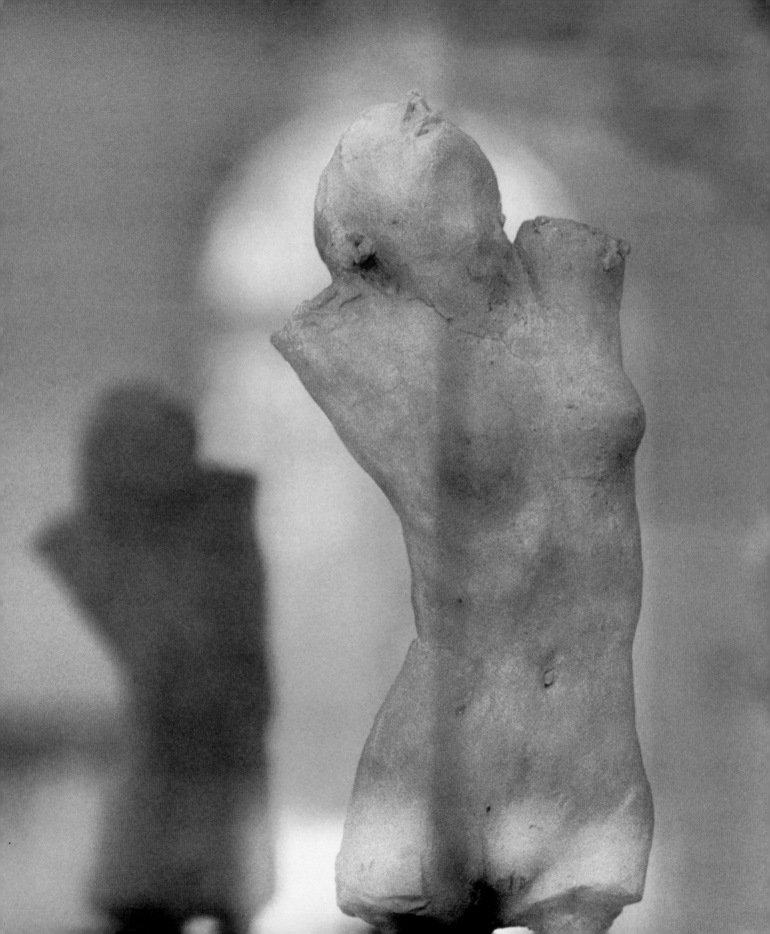

TORSO OF THE CENTAURESS
c. 1884, *terracotta*

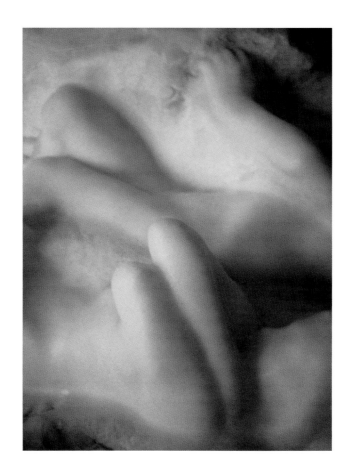

Genesis

MY FIRST REAL CONTACT WITH RODIN'S WORK was in February 1996 while I was living in Paris for a few months. I associate this period not only with Rodin but with the appearance of Michelangelo Antonioni's film, *Par-delà les Nuages*, which I saw three or four times in as many weeks. The film is a collection of short stories, each taking place in different locations – both France and Italy – in contrasting architecture, weather and light. Each story relates an encounter of a different nature between a man and a woman. The locations in the scenario are particular: foggy Comacchio; narrow, lamp-lit streets in Aix-en-Provence; the massive walls of historic Ferrara; steep, hillside steps of Portofino running down to the harbour, and the stark glass interior of a modern Parisian penthouse, to mention a few. The action of the protagonists is bound into this geography of place, space and light.

At the Hôtel Biron in Paris, Rodin's own eighteenth-century chateau where he lived and worked, the sculpture inhabits its own environment. The architecture is grand with spacious rooms and high ceilings. Light streams in through generous casements. In the reception rooms, great wall mirrors in elaborate frames reflect light and objects. At the Villa des Brillants in Meudon, his country retreat, Rodin erected a huge pavilion in the garden for his full-scale plaster studies. Here, there are a number of glass cases (for tiny sculpture) constructed nineteenth-century-style with light-reflecting mirrors, which is a neat way of improving the natural illumination of the display. More exciting than the practicalities is the miniature world through the looking-glass, measured in inches rather than feet or furlongs.

On my first visit to the museum ten years ago, my attention was drawn initially to a couple of works, both compositions of lovers. One, *Eternal Idol*, stands before a rococo mirror upon a high mantelpiece. This plaster sculpture is protected by a Perspex box. A man kneels, leaning forward, his head bowed towards the breast of the woman. She is kneeling erectly and looking a little smug. Around the couple, there is a teasing, endless game of geometry with light, cast shadows and reflections playing across the space between window, transparent box, mirror, object and the eye, or lens.

A big chunk of white marble in the same room caught my eye for other reasons. *Adam and Eve* is displayed at knee level on a low plinth. The subject generally conjures up in the imagination a composition similar to the classic series painted by Lucas Cranach: the moment of Temptation. The couple stand side by side, Eve offering the fruit to Adam and, in the background, the serpent dangles in anticipation from the Tree of Knowledge. In contrast, Rodin has the viewer acting God, witnessing the scene from above. Adam and Eve are lying on barren ground *post-coitum*, having already turned away from each other, their passion spent. Etched into the rock face sheltering the couple, the serpent hangs like a limp length of rope.

The Genesis story particularly interested me. It puzzled me. At the time, I happened to be writing (for myself) a 'more complete' version of events in the Garden of Eden. That day in the museum, I had my 'Mickey Mouse' Pentax Auto 110 in my pocket and, for amusement, made some colour photographs of *Adam and Eve*. I was surprised by the results. In the mix of natural and tungsten light, the pictures were almost abstract. The camera, evidently, had been working its mystery with the given material. I was keen to explore and discover more.

Over the years, I have returned almost obsessively to the Hôtel Biron and the Villa des Brillants with my camera. For all the photographs, I use available light and 35mm film. I carry no tripod, which I find cumbersome and inhibiting. This business of looking, deciding, experimenting is sometimes slow, but is more often an urgent affair. So far, my few attempts at black-and-white photographs in the museum have been useless for my purpose. Maybe Rodin's sculpture simply enjoys, for a change, the voluptuous qualities of colour – the revelation of its own extraordinary energy source bathed in colour, and its rapport with the ever-changing colour and light of its surroundings?

JENNIFER GOUGH-COOPER

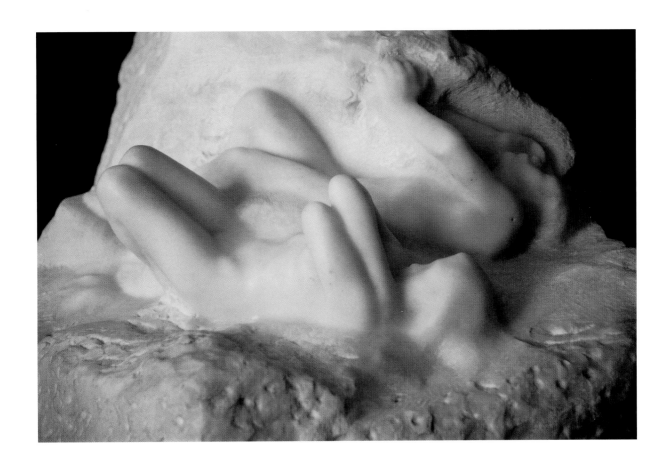

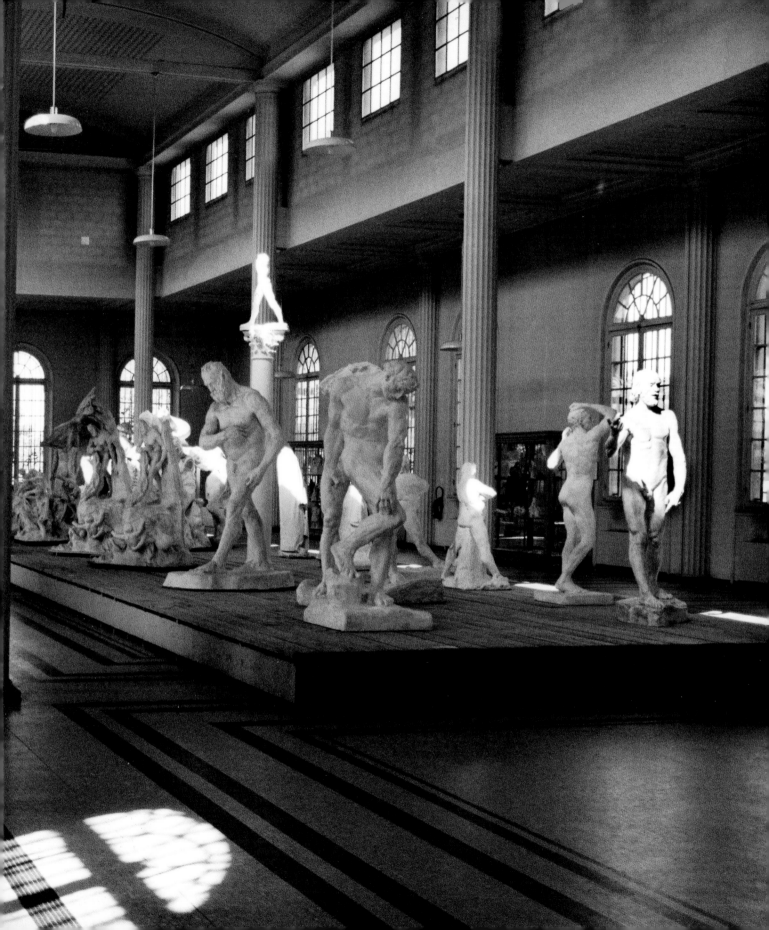

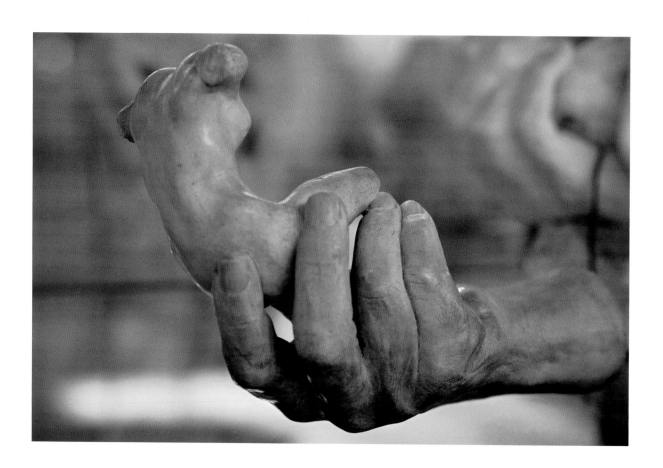

Notes

The Awakening of Stones

1 *Art and Revolution*, London: Weidenfeld and Nicolson, 1969, pp. 73–74. Berger writes at length about Rodin in the essay 'Rodin and Sexual Domination' in *About Looking*, London: Writers and Readers, 1980, pp. 177–84
2 *Selected Letters 1902–1926*, London: Quartet, 1988, p. 1
3 Quoted by Ruth Butler in *Rodin: The Shape of Genius*, New Haven & London: Yale University Press, 1993, p. 376
4 *Ibid.*, p. 378
5 *Ibid.*, p. 375
6 Quoted by J. B. Leishman in introduction to *Rilke: Selected Poems*, Harmondsworth: Penguin, 1964, p. 15
7 *Selected Letters 1902–1926*, p. 32
8 *The Book of Images*, translated by Edward Snow, New York: North Point Press, 1994, p. 19
9 *Selected Letters 1902–1926*, p. 4
10 *Rodin and Other Prose Pieces*, London: Quartet, 1986, p. 4
11 *Cathedrals of France*, Feltham: Country Life Books, 1965, p. 269
12 Quoted by Catherine Lampert in *Rodin: Sculpture and Drawings*, London: Arts Council of Great Britain, Yale University Press, 1986, p. 84
13 *Ibid.*, p. 66
14 *Rodin and Other Prose Pieces*, p. 15
15 Translated by Shaun Whiteside. For full text of poem in German original and alternative English translation, see *The Book of Images*, p. 80
16 *Rodin and Other Prose Pieces*, pp. 52–53
17 *Ibid.*, p. 9
18 *The Language of Sculpture*, London: Thames & Hudson, 1985, p. 21
19 *Selected Letters 1902–1926*, p. 32
20 *Rodin and Other Prose Pieces*, p. 39
21 *Cathedrals of France*, p. 57 and p. 10
22 *The Poetics of Space*, Boston: Beacon Press, 1969, p. 239
23 *The Complete French Poems*, translated by A. Poulin, Jr, Saint Paul: Graywolf Press, 1986, p. 67
24 *The World as Sculpture: The Changing Status of Sculpture from the Renaissance to the Present Day*, London: Chatto & Windus, 1999, p. 339
25 In Vicki Goldberg (ed.): *Photography in Print*, Albuquerque: University of New Mexico Press, 1988, pp. 46–47
26 Quoted by Larry J. Schaaf in *The Photographic Art of William Henry Fox Talbot*, Princeton: Princeton University Press, 2000, p. 80
27 *Nude Sculpture: 5000 Years*, New York: Abrams, 2000, p. 6
28 *The Body in Pieces: The Fragment as a Metaphor of Modernity*, London: Thames & Hudson, 1994
29 *The Originality of the Avant-Garde and Other Modernist Myths*, Cambridge, Mass., & London: MIT Press, 1985, p. 153 and p. 156
30 Quoted by Jane R. Becker in Dorothy Kosinski (ed.): *The Artist and the Camera: Degas to Picasso*, New Haven: Yale University Press, Dallas Museum of Art, 1999, p. 91
31 *Ibid.*, p. 91
32 *Cathedrals of France*, p. 60
33 Anthony Barnett, 'The Hand of God', *Art Monthly*, December/January 1987, p. 7
34 Quoted by Joel Smith in *Edward Steichen: The Early Years*, Princeton: Princeton University Press, Metropolitan Museum of Art, 1999, p. 35
35 Quoted by Becker, p. 106
36 Quoted by Annie Cohen-Solal in *Painting American*, New York: Knopf, 2001, p. 186
37 *Cathedrals of France*, p. 94
38 *Paradise Lost* (Book X), London: Longman, 1971, p. 547
39 Quoted by Butler, p. 203
40 *The Collected Poems of Wilfred Owen*, London: Chatto & Windus, 1963, p. 58
41 Quoted by Lampert, p. 150
42 *Paradise Lost* (Book IX), p. 496
43 *Villages*, London: Hamish Hamilton, 2005, pp. 319–20
44 Quoted by Lampert, p. 150
45 Quoted by Anne-Marie Bonnet in introduction to *Auguste Rodin: Erotic Drawings*, London: Thames & Hudson, 1995, p. 12

Sources of Quotations

J. Cladel, *Rodin: The Man and His Art, with Leaves from His Notebook*, New York: Century Co., 1917
B. Garnier, *Rodin: Antiquity Is My Youth*, Paris: Editions Musée Rodin, 2002
A. Rodin, *Cathedrals of France*, Feltham: Country Life Books, 1965

List of Illustrations

All photographs were taken at the Musée Rodin, in Paris or Meudon, except BALZAC, BAUDELAIRE AND PUVIS DE CHAVANNES on page 18, which was shot at the exhibition 'Rodin en 1900', Musée du Luxembourg, Paris, 2001. Dimensions of works are given in centimetres and (in brackets) inches, height before width before depth.